PARANORMAL SOMERSET

SONIA SMITH

AMBERLEY

To my constant companion while I work, my little English Bull Terrier Jackie, whom I really think is a pooka. I did not start to write until she arrived in my life seven years ago.

First published 2010

Amberley Publishing
Cirencester Road, Chalford,
Stroud, Gloucestershire GL6 8PE

www.amberleybooks.com

British Library Cataloguing in Publication Data.
A catalogue record for this book is available from the British Library.

ISBN 978 1 84868 565 9

Typesetting and Origination by Amberley Publishing.
Printed in Great Britain.

Contents

Foreword

It is shocking to say that all of the stories in this book are, in fact, true. The places named are real. So too are the people.

Some people have asked that their actual names be changed, and I feel in this I must oblige. The paranormal is still a bit of a taboo subject. Well, it is if you are the one who has experienced it. It leads some to think that their job will be in jeopardy or that they will lose the respect of friends and family if they openly say that they have experienced such things. They fear being dubbed as strange, or even crazy.

This is, of course, a shame in our so-called enlightened times. After all, we are just waiting for science to catch up with these sorts of phenomena, and to spoil it all by telling us this and that, by taking away the mystery. But for now we shall enjoy that mystery.

It is true that I have taken solid facts and woven them into more of a story to entertain. But please remember that facts can be stranger than fiction. All of the stories are based on the true and often detailed accounts of people from all walks of life, and all ages. These people mainly come from the West Country, or have moved here.

To them I am greatly indebted, and also honoured that they saw fit to share their amazing experiences. I hope you enjoy them all as much as I have!

Sonia Smith
October 2010

Little Girl Lost

Raymond Forbes parked his Land Rover where he always parked, behind the sand dunes. Pollyanna, his white Bull Terrier, who had a rascally patch, was barking with the excitement of an impending walk along the beach. Raymond and Polly had done this walk three times weekly at Burnham-on-Sea since Polly was a pup some four years ago.

Raymond, a tall and rather angular man, worked for the forestry commission in administration, so nowadays he rarely had hands-on work in the forest. And so it was as much a pleasure for him as Polly to go and get some sea air and freedom.

Today it was Saturday, and Polly and Raymond had shared a fish and chip lunch in the town together. Polly was Raymond's constant companion; she even went to work with him. Raymond's wife Fiona would joke and say, 'Raymond has three loves in this order: Polly. Forestry work. Me.'

Apart from his obvious eccentricity – adoring all Bull Terriers – Raymond was said to be, by both his wife and his friends, a very level-headed man. He was not prone to storytelling and certainly did not have any leanings towards believing in the supernatural.

So on this rather murky day in early February of the year 1999, Raymond and Polly set off along the beach. Polly was dancing on her hind legs, begging for Raymond to throw a stick. Raymond pulled the collar of his coat up, and put on his woollen hat against the bracing sea breeze.

There were very few people on the beach. He could just see in the far distance a couple of dog walkers. They had what looked like a bloodhound and two dachshunds with them. Raymond smiled; a funny mix, that.

Raymond threw the stick, and Polly raced after it. The tide was out, so Raymond was very careful to keep Polly well out of the way of the quicksands. These were about 500 yards out from some parts of the beach. There were signs warning everyone to keep well clear, although tragedies had been known to occur when the signs were either not seen or not heeded. All of the locals knew about the danger but unwitting tourists were sometimes not so lucky.

Polly was now barking loudly and nudging the stick, which meant that Raymond must throw it again. Raymond looked up at the leaden sky, and then out to the grey line on the

Don't do it, Raymond! (*Silver Star*)

horizon. A slow fog was creeping in from the sea. Raymond shuddered involuntarily. He was not sure why. It must just have been the chill on the air.

'I think we'll have to make it a shorter walk today, old girl.' he said apologetically to his dog. 'The fog is coming in and we won't see where we are going soon else. We'll go a little further, and then head back eh?'

Polly looked a little sorrowful, as if understanding exactly what was said. Then, Bull Terrier high spirits suddenly getting the better of her, she ran around and around in circles, ears tucked tightly back against her head. She jumped at Raymond, and sent him flying down on his backside with a thump.

Raymond got up, brushing the sand from his clothes and laughing. As he threw the stick again for Polly he saw a small girl running along the beach with a red kite on a string. She looked to be about three years old. She wore a red plastic Mackintosh and navy Wellington boots with white polka dots on them. Her dark curls were tossed by the breeze as she ran. She was laughing at the kite.

Raymond's first thought was to get Polly on a lead. She adored children, and could be too exuberant in her greetings. Her bouncy, bounding, hard rubber ball of a self was just too much for most small children. And doggy kisses were not always welcome; they are definitely considered unhygienic by most concerned parents.

But, strangely enough, Polly was taking no notice whatsoever of the little girl, and was completely engrossed in digging some scallop shells from the sand. Raymond looked around, waiting to see the parent, or parents, of the little girl appear. But oddly there was no one else around.

The quicksand and the dead. (*Silver Star*)

Raymond went over and clipped on Polly's lead. She looked very indignant at this, and looked askance at him, as she did when she saw no good reason for her freedom being curtailed. But Raymond was now too worried to think of much but the little girl, who was still flying her kite and skipping along the beach, seemingly oblivious to the fact that she was quite alone except for a stranger and his dog.

Raymond was now further concerned by the fact that the stealthy grey fog had crept further inland. Soon it would become so thick that it would be hard to see one's hand in front of one's face. He had seen it many times before. It could be lethal if you were anywhere near the quicksands. It could come slowly or at lightning speed, and lift just as unpredictably. The little girl was all alone, and getting dangerously near to the mire.

Raymond gazed around in all directions, hoping to catch sight of someone coming for the little girl. But there was no sight of anyone at all. The beach was empty. Was this child lost? She didn't look lost or frightened in any way. She was still looking at the red kite, which bobbed at the end of the string, sometimes losing height and crashing. Then she would throw it up again into the wind and watch it fly.

Raymond was afraid that if he called to her he might startle her. But his mouth was going dry and his heart was pounding at the thought of her going too near the quicksands. She was still heading that way. Another hundred yards or so and she would be past one of the signs.

Suddenly she turned to look at him, letting the kite fall as she did so. Her face was very pale, and her eyes had a peculiar look about them. She seemed to look right *through* him. Then, suddenly, she picked up the kite and started to run into the fog, going nearer to the impending danger.

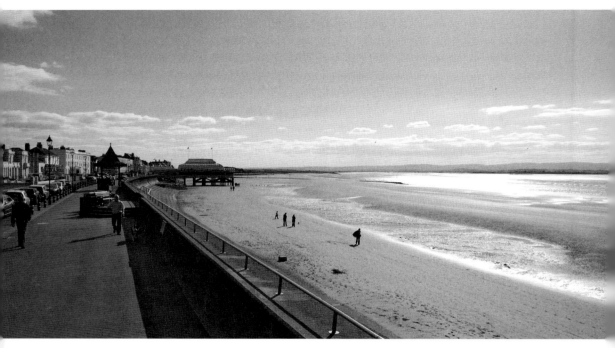

Windswept Burnham-on-Sea. (*Silver Star*)

At this point Polly began to bark. Her bristles were all up, and she barked like she did at home when she saw something or someone she was unsure of. She usually never did this at children. This set Raymond's already frayed nerves further on edge. 'Shut up Polly!'

Then Raymond realised that perhaps Polly had recognised that the little girl was in danger. He started to run, trying to catch up with the child. Calling softly to her. Trying not to drive her further into the quicksands. Finding it hard to see her in the gathering fog.

Then, to his relief, he caught sight of her. She was just a little way ahead. She was playing with the tail of the kite in her hands. To his dismay, Polly tugged the lead from his hands, and ran back towards the beach a little way. Then she just stood there barking, as if trying to tell him something. He turned back from watching his dog to find that now the little girl was skipping along the very edge of the quicksands.

'No!' he shouted. 'Hey, little girl! Come back here!'

But the little girl just turned and smiled at him, and walked on, her red kite dangling from her arm.

'Oh my God!' The words escaped involuntarily from Raymond's lips as he found his boots sinking in the sands at a rapid rate. The sands were brown, sodden, and muddy underneath the innocent layer of white sand.

Raymond was struggling now; his feet sinking fast. Soon the mire would be up to mid-shin. He was sweating, and his heart was racing. The little girl was nowhere in sight. A strong wind had come in from the sea, dispersing the fog as rapidly as it had arrived. Suddenly he could see for miles. There was no sign at all of the little girl.

Now he was fighting to get out of the sands. On looking around he realised that he had followed the little girl way beyond the danger signs.

Then Polly was in like a flash. She was pulling him by the coat. Tugging for all she was worth. Raymond was shouting for her to get back. He was desperate now. Afraid that Polly too would sink into the sands. But she continued to tug, and dragged him free of his boots, skidding him along the wet sand on his back. Polly's legs had sunk in right up to her belly, but her strength and tenacity held her in good stead. Both she and Raymond were now covered in the filthy sludge.

Then he saw the bloodhound he had seen earlier appeared, followed by the two yapping dachshunds. The owners of the dogs, a middle-aged man and woman, were racing towards him. They helped him to his feet. Polly stood exhausted and shivering next to him.

'Don't you know about the quicksands?' the man asked Raymond rather severely. 'Looks to me like your dog just saved your life. Are you stupid or something?'

'Jerry. Please.' the woman said to her husband. 'I am sorry. We are rather shocked. We thought... It looked like you might not get out. Are you alright?'

'Yes.' Raymond found that he was trembling. 'I followed the little girl. I was afraid that she might sink into the sands and not get out. Did you see her? Did you see where she went? She was right next to me...'

'What little girl?' the man asked incredulously. 'We could see you clearly as the fog lifted from along the beach. You were quite alone. Your dog seemed to have more sense than you. She was barking at you, we could see and hear her. And you just kept on walking towards the quicksands. We couldn't believe it!'

Raymond felt disorientated. His head swam. He felt that he might topple back onto the sands. He thanked the couple, and quickly marched away towards the dunes where his Land Rover stood. A bewildered Polly followed on his heels, caked in mud.

The couple stood, watching him go. Their dogs milling at their feet. The man was shaking his head. The woman just was staring after him.

Raymond could never face going to the beach at Burnham after that. And he never did know the answer as to the little girl...

The Glastonbury Tor Horror

It was early summer in 1993. Vilna Hayes and her boyfriend Robbie Harberd were on a camping holiday. They were both university students. Robbie was twenty-one, Vilna twenty. They had decided to go camping at Glastonbury, as Robbie's aunt lived there. It was convenient to have a place to go should it rain or turn cold.

Vilna was tall and slender, with thick blond hair that fell to her waist. She had a few faded freckles across the bridge of her rather beguiling tip-tilted nose, and her eyes were a pale green. She had a habit of telling everyone that it was rumoured that her grandmother had been one of H. G. Wells' lovers. She carried a copy of *The Time Machine* around with her and wrote myriads of unfinished novels in the pursuit of any kind of literary talent that she may have got from her 'grandfather'.

Robbie was tall too. And what he lacked in looks, he made up for in intellect. He had an open, honest face, and slightly protruding teeth. His hair was nut brown, his eyes the colour of maple syrup. He had no interest in the spiritual or the paranormal. It was Vilna who persuaded him to holiday in Glastonbury.

Neither had been to Glastonbury before. Vilna had lived in Reading all her life, and Robbie had lived with his parents in Newbury. Robbie's aunt had lived in Glastonbury for eight years.

Vilna had wanted to see Glastonbury. She had heard that it was a Bohemian type of place where artists, writers and musicians could be found. Not to mention the hippies, the New Age travellers, occultists and modern-day witches! It sounded like a pretty exciting place to Vilna. Robbie wasn't so convinced. He didn't think there would be much excitement to be had among a lot of stoned, drunk and rather smelly people. Or those deluded creatures garbed in heavy black velvet, with huge pentagrams dangling from their necks on thick silver chains, hoping surely to strike awe in their beholders.

Despite all this, Robbie and Vilna spent a whole day down in the town of Glastonbury on their arrival. It was a warm and glorious day. The sky was a paintbox of vivid blues and bright white clouds.

The town was buzzing with tourists. People were dressed in a sparkling array of clothing. Stunning girls strutted the streets in short shorts, showing off long tanned legs. Lean and

muscled men with dreadlocks wore baggy pants and multicoloured bandanas. Fat bra-less ladies, unabashed, wore skimpy tie-dye dresses. Old men with long grey hair and broken-toothed smiles wore long tunics, and carried ornate staffs. Slender girls in green velvet wore garlands of flowers in their long silky hair and looked like Arthurian maidens.

From the open doors of some of the shops came a mixed perfume of marijuana, Nag Champa and cigarette smoke. The shop windows had brazen Sheela na Gigs and statues of dancing Shivas and phallic nature gods, all alongside the Virgin Mary and depictions of Christ on the cross.

Vilna loved it all. Even Robbie had to admit he was impressed at the diversity. They lunched in the George & Pilgrims, a very fine fifteenth-century hotel in the high street, all beams and the smell of beeswax. Vilna showed Robbie all of the little curiosities she had bought. Robbie enjoyed a good pint of beer, nutty and bitter in taste, and Vilna sipped at lime and soda on ice. They had lemon sole, salad and fries, and lemon sorbet for afters.

In the afternoon they went and visited Robbie's aunt Isabelle. She lived in a little, rather tumbledown house, on the Street side of Glastonbury. Her small garden was a riot of bluebells, late tulips, and tall purple irises. They stopped and had Earl Grey and shortbread biscuits with her, before moving off to find where they might camp.

Robbie had it in his head that they would camp at the foot of the Tor. They had glimpsed it on their way into the town. It is an amazing natural phenomenon. The child of an ancient earthquake. A place of pilgrimage for pagans and Christians alike. Dion Fortune's 'Hill of

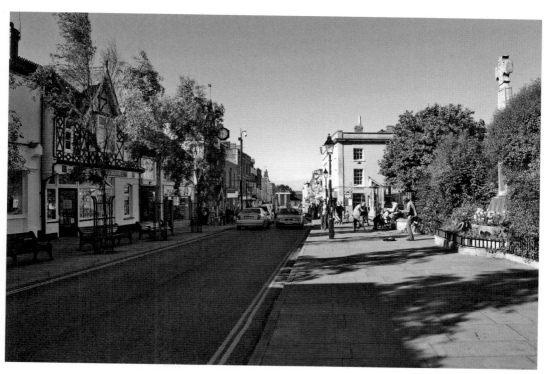

Glastonbury by day. (*Silver Star*)

11

Vision'. It seemed to breathe. It had life. It had its very own spirit. It stood magnificent and unmoving in the sunlight, a sleeping leviathan on the landscape. A serpent dead to the world, but ready for awakening.

As they turned up the little lane leading to the Tor, Vilna was convinced that they would be unable to camp there. 'The National Trust will not like it Robbie,' she said as they pulled into the lay-by at the foot of the Tor.

'Then they will have to lump it!' replied Robbie, ever the rebel. Pulling on the hand brake of the little Citroën. 'Just look at that little orchard there at the side of the Tor, Vilna! Did you ever see a more prime place to camp? Plenty of wood too for a fire. We'll be well away!' Robbie was out of the car, pulling a light woollen jumper over his t-shirt.

They locked the car and half ran through the gate and up the track towards the Tor. The ruined church on top was silhouetted against the bright blue sky, like the one decayed tooth left in a monster's head.

Despite Vilna's remonstration, Robbie set up camp in the little orchard at the foot of the Tor. Vilna had soon given in. There were many twisted and gnarled old apples trees here, and they were covered in delicately perfumed pink apple blossom. It was like Aphrodite's bower.

After they had investigated the Tor and the wonderful views from the summit and had tried to make out the Glastonbury Zodiac in the surrounding landscape (which Vilna had so ardently read about), they came back down to the orchard, and made a cup of tea with the little primus stove that had belonged to Robbie's father.

They sat on a tartan blanket together; Robbie's arm around Vilna's pretty bare shoulders. They kissed, as lovers will, amid nature's glory. Robbie had never felt so happy and relaxed in all of his life. And Vilna was quiet for once, in her contentment.

Soon the lovely day came to its close. They watched the sun set in the west. A blood red glow illuminated the sky all over with reds, pinks and purples. They watched this together from the Tor, sat with their backs against the grey stone of church walls. There were a few straggling tourists taking photographs of the sunset. A loose lurcher with an orange-brindled coat ran around the Tor top, wildly chasing invisible rabbits.

Soon Robbie and Vilna headed down to their tent, hidden among the apple trees. They made a makeshift supper of fried egg sandwiches on the stove, and washed them down with some good local cider.

Very soon they were both tired. It had been an eventful day. And what with the heat, the travel, and the excitement, they both decided to bed down for the night.

At about two in the morning the call of nature woke Robbie. Too much cider. He was bursting for a pee. He took his torch, making sure not to wake Vilna, who was sound asleep, her mouth slightly open and her blond hair in a glorious mane on her pillow.

As he left the tent an owl hooted somewhere near. The sky was ink, and it shined with the polished diamonds of the starry firmament. There was a sliver of bright moon. He walked well away from the tent and into the field to relieve himself. He was about to head straight back to Vilna when something caught his eye.

He moved stealthily, and got closer to the east side of the Tor. Soon he was running along the spiral path that climbed the Tor to the top. When he was halfway up he could see a group of men, or at least their outlines. Three of the men seemed to be carrying something. It looked like they had huge long logs across their backs. They were bent under the weight of them. The other men were not carrying anything. But one of them was hitting the three men with something as they laboured up the slope of the Tor with their burdens.

He could see their shapes plainly up ahead of him. They were all now on the summit. Robbie followed, intrigued. What the hell could this be? Was it some sort of local rag? Was it a sick ritual of some kind? The men carrying the logs sounded in real distress.

Robbie hid himself inside of the earthquake-ruined St Michael's Tower. He thought that he heard one of the men cry out in agony. He decided that enough was enough. He would have to confront these people, whatever they were doing. His mouth had gone dry. His heart pounded. This could be dangerous. And what about Vilna, down there all alone? He found that he was sweating, and one of his legs had a tremor.

He peered around the edge of the opening of the tower. A cold wind blew through the gap and hit him in the face, making his eyes water as he looked cautiously out. What he saw actually brought him to his knees with fear.

There were three gibbets set up outside. And the men who had been carrying the logs were being hanged on these by the other men. The logs, or whatever they were, lay in the grass at the foot of the ruined tower. Robbie covered his face in horror. But he looked again, trying hard to know what to do. He saw the three men, swinging in the breeze on the end of the ropes, their bodies now horribly limp. He could smell urine and faeces.

He was crouched inside the tower, trembling all over. He held his hand to his mouth. 'Oh my God! Oh my God!' he said under his breath. Even his fear of discovery could not prevent his distress. He thought that he was about to vomit.

Then something very strange happened. The whole scene disappeared before his eyes. All he could see now was the starry sky and the shadowy shape of the grass outside. No men.

Ynys yr Afalon, or Glastonbury Tor, as seen from the Chalice Well Gardens. (*Silver Star*)

No gibbets. All was quiet, except for the wind whistling through the old ruined tower. He was quite alone.

The next day, after having had no sleep at all after his adventure, Robbie related what had happened the previous night to Vilna. They were in the car, ready to leave. Robbie had no stomach to stay any longer. He was also afraid of the kind of madness that could have possessed him to witness such strange things in the middle of the night. Things that could not have actually happened.

Vilna put her sunglasses on, ready to drive. She said nothing for a while. Then she turned to Robbie before starting the engine and squeezed his hand affectionately.

'I shouldn't worry about last night,' she said.

'You joke,' replied Robbie. 'I really don't know what happened to me. But it scared the life out of me.'

'You know that a man called Richard Whiting, I think he was a former abbot at Glastonbury Abbey, was hung on the Tor?' said Vilna.

'You what?'

'Yes he was,' she continued, 'and two of the priors were hung at the same time with him. They were made to climb the Tor with their arms roped to hurdles before they were hung. This was after the dissolution of the monasteries by Henry VIII in 1539.'

'My God Vilna! How do you know all of this?'

'Robbie, I read it this morning in the guidebook I picked up in the town yesterday.'

Robbie sat dumbstruck. It was dawning on him that he had witnessed a very gory bit of history, some 450 years after the event.

Enlightenment at the Holy Well

Maria Carswell stood at the paygate of Chalice Well Gardens in Glastonbury. These lovely gardens stand at the foot of the famous Glastonbury Tor. The well springs that run out from under the great mound of the Tor collect into various outlets. And dug into one of them is the Chalice Well. This well and its adjacent springs are said to contain in its waters the blood of Christ. Joseph of Arimathea brought the cup from the Last Supper and washed it there. Others think it the source of life emanating from the Earth Goddess. Either the menstrual blood that speaks of fertility or perhaps the afterbirth.

Either way, it is a place of great pilgrimage. A sort of Somerset Lourdes. People travel there from all around the globe to drink the waters and rest there in the hope of healing or inspiration. The gardens are stocked with beautiful flora, and what with the ever-flowing waters and the quiet, constant surge of the spiritual, the gardens have a heightened tranquillity.

Maria was not alone the day she stood at the gate. Her husband, Edgar, was with her. A queue of people stood behind them as Edgar fumbled in his pockets. He declared, in a loud voice, 'I've only enough money for me to get in. Did you bring your purse? Why oh why should I always be paying for you anyway?'

The lady in the kiosk shot a pitying glance at Maria, who was now scrabbling around in her handbag for her purse. People in the queue nearest to them shuffled uncomfortably. Those at the back showed signs of impatience. Maria went over to the counter and counted out her change. All that she had in her purse. Just enough, save for a penny. The woman in the kiosk got a penny out of her own purse and put in the till, glowering at Edgar as she did so. Edgar ignored her, and his wife, and went in through the gate to the gardens. Maria followed.

'I don't know why on earth you wanted to come here. It is just a garden. Our garden at home is as good as this, if not quite so large. And as for all the bunkum about this place. It's rubbish! That's what it is. Rubbish!' He turned and glared at his wife.

Maria said nothing. What was the point? She had stopped replying to Edgar most of the time long ago. Edgar was mostly interested in his own opinions. His mother had never allowed him any of his own when he was a child, and now he made up for it.

A woman and her teenage daughter passed them on the path. Edgar raised his summer straw hat, and looked them over in an appreciative manner. 'Young and lovely. And the mother not bad either. So slim.' Maria kept her eyes on the path.

'Why can't you be like that Maria? Look at you. Whatever you wear looks all wrong. You are messy. Look at your hair. And you have grown quite fat. Thick around the middle. Only fifty-five and you've let yourself go! My mother is seventy-eight years old and slim as a corn stalk. You can't achieve that even at your age!'

Maria continued to follow, her eyes just slightly moist. Years ago she had broken down at such words from Edgar. But now she had toughened just enough to cope.

'And pray what are we supposed to do in this place?' asked Edgar, throwing his arms wide apart in a dramatic gesture. 'Drink the water? Of course it tastes of blood! It wouldn't be the iron content? Or maybe we should light some joss sticks and prance around calling on the non-existent angels and fairies? Or maybe the gods? Those puerile imaginings of obviously crazed minds?'

People were staring at him. This only induced Edgar to perform further. 'Well Maria. What do we do? Shall I strip off and bathe in the waters and get close to Mother Earth? But don't you do it, for God's sake. Who would want to see you waddle down into the water in the nuddy? And full sunlight at your age and condition isn't very flattering.'

'Why don't you go and get an ice cream?' Maria said, quietly.

'What was that you said? Speak up! Did you tell me to go and get an ice cream?'

Edgar strutted around a bit, obviously too indignant to speak. Maria had always thought of him as tall and elegant. But today he looked just gangly and, if truth were known, Gollumish.

'I'll tell you what,' he said, facing Maria and looking menacing. 'I am not going to get an ice cream. I am going into the town. And guess what? I am going to the pub where I can get a drink, sit in the sunshine, look at the pretty barmaids, and read the newspaper. And not waste my precious time in a place like this with a dolt like you!'

'Edgar please. Not drinking.' Maria's voice was plaintive and fearful.

'Edgar please. Not drinking,' he mocked. 'Too true I'll be drinking! This bloody place is enough to drive anyone to drink. Let alone you. I'll come back when I am good and ready. Could be a long wait. Could be a short one. We shall see what happens. Enjoy your stay in the land of the gagas.'

He strode off without looking back at her. Maria's heart was pounding. She knew what this meant. It meant a nightmare drive all the way home to Frome later. Edgar at the wheel. Either all over the road, or pretending to fall asleep just to scare her. A danger to themselves, and worse still a danger to others.

Maria, the shadows gathering inside her, just collapsed on the nearest seat. She pushed a hand through her faded and fluffy blond hair, and tried to compose herself. But it was no good. Her hands shook, and tears gushed down her cheeks. She was sat in the area where the Chalice Well Head was, although she had not noticed where she had walked at all. A couple of people moved off, having reverence for her distress. Many people who came to the gardens were in a state of distress. It was not unusual in this place.

Little tea lights burned in recesses in the stone walls. Candles of hope or prayer. Offerings, placations, and prayers to different gods or goddesses. From Christ and the Virgin to Aphrodite and Gaia. Maria's heart almost broke at the sight of them. So many heartfelt thoughts and feelings in each candle. Thirty years of pain and sorrow welled up inside of

her. Yes, thirty! Even she had to admit it now. Edgar had been like it from the beginning. He was his mother's son. Truly.

Maria remembered herself back then. Lively. Pretty. Slim. Her long blond hair falling down her back. Her joy at the birth of the children. Edgar only saw them as another financial encumbrance. 'You are all a millstone around my neck,' he would say, 'all of you!'

He would invite his mother to the house and it was like a royal visit. And they would both go around like health inspectors, pointing out where the children had dropped a rusk. Or the muddy paw prints from the cat or dog. Or the washing up left in the sink when one of the children was ill and Maria had no time to do it. And they would complain that clothes were not ironed, and floors not washed. And why? Oh, because Maria, that messy, idle thing, was either playing with the children or painting those useless pictures in the back room. Instead of being a proper wife and keeping a spick-and-span house, she let the children run wild and would not smack them. And let them mess the house up with their toys. Sticky fingers all over woodwork. Sometimes scribbles on the walls! Maria was a slut!

Those useless pictures... Oh how she missed painting those useless pictures. Some people even liked them. Bought them. But she had stopped painting them long ago. Even though the images called to her. Pleading to be born. Put into form. She denied them birth and felt like a murderer. But she could not bring them into the world to be ridiculed just like herself, by Edgar.

The loneliness of years welled up inside her, a great tidal wave that only could find release in spilt tears. Sat there, in a beautiful garden, on a sunny day in June 1987. Why had she

The Well Head. (*Silver Star*)

come here? People quietly shuffled in and out to see the Well Head. If they noticed her they turned their heads away in a kind of veneration of her grief. Maria had never felt such detached sympathy.

Her mind wandered back, allowing her to see. Really see. She did not wipe away the tears. She let them trickle shamelessly from her chin, joining the mucus from her nose to make a fountain that fell to the earth.

She tried to remember when she had died inside. When the flame was almost extinguished. Was it when she realised that Edgar had periodic flings? They couldn't be called affairs. One-night stands, picked up in pubs, well into his cups. Always instigating an argument with her first, then storming off and leaving her alone in the house with the children all night. Staying at his mother's house for days sometimes. Telling her on the 'phone that he wanted the family home sold. Saying that he wasn't coming back. But always coming back, making sure that the torture was complete by small evidences of his adultery. It was her punishment. Mainly it was her punishment for loving him.

Or was it when she realised that her friends had slipped away? They called no more at her house. They could not stand Edgar's flirtations under his wife's nose. Or the rudeness and the black moods that drove them to leave before time.

Was it when the children left home? They couldn't wait to get away. And who could blame them? Mother and father fighting. Yes, Maria used to fight. Then, after the fighting stopped, on Maria's part; the long silences. The cheerless house. Everyone in separate rooms, doing different things. Conversation with Edgar too much of a minefield for anyone, especially if he had been drinking.

Or was it when she had realised that Edgar might be right. She was a useless lump. She had tried a job at the supermarket. Edgar's mother had said that she should get a proper job. Help out with the finances. Take the strain from poor Edgar. Edgar agreed wholeheartedly – his wife was a parasite. She should stop all of that art nonsense. It was only a few pounds here and there when she sold a picture. Not a proper wage. It was not a proper job.

She had lasted one day at the supermarket. She could not even get the hang of the till. They had been kind, but had told her it wasn't going to work. They had replaced her with a pretty but backward seventeen-year-old, who could use the till like a demon.

But no, she realised now for sure that the flame had turned to embers when she no more teased paint onto canvas. No more allowed her treasure house of images to live. When the summer morning air no longer had the waft of oil, and captured light and shade.

It was with this realisation that the voice came to Maria in the Chalice Well Gardens. First there was a blinding light. She could not see. It frightened her. And then a woman's voice said, 'Lady of the Bitter Sorrows. Marah. Star of the Sea. Lift up thy head and rejoice for the waters flow again.' And then she felt a tender kiss on the middle of her forehead. And the blinding light was gone. Maria felt an ecstasy before unknown. She felt as though her body had been filled with warm and radiant light.

Maria, unsteady on her feet, made her way to the Lion's Head, where the red water springs forth. She cupped her hands and drank. The water was as blood in her mouth.

There and then, filled with courage and still glowing from the lady's kiss, she decided to call her daughter and tell her that she was coming to stay awhile. She was not going home with Edgar. She was never going home again. She would find a flat or a little house here in Glastonbury, and paint.

The Wailing Ghost of Chard

It was 1 September 1979. Lucy was never to forget that date. It was engraved in her memory. It was the day that she and her baby daughter moved into a small terraced house in Chard. Before this she had never known what true horror might feel like. Or a creeping presence that made her night-time existence a living hell.

Lucy was twenty-two years old, her baby eighteen months. She had become a single mother. And, despite the swinging sixties and the changing social attitudes of the seventies, she found herself on the outside of life.

Her ex-boyfriend, known to all as Gramm, had unceremoniously dumped her. He had moved in with her for a year in a house provided by her parents. They had been happy. Or she had thought so. But the parties had become very noisy and drugs had been too openly consumed. The straw that broke the camel's back was that Gramm had grown marijuana in the little back porch in huge pots. The landlord had found it and called the police. Gramm got a caution, and they were evicted.

Lucy's father, an airline pilot, refused to pay any more rentals. Besides this, Lucy's mother refused to speak to her anymore. Both her parents disapproved of Gramm. They had disapproved of him even before the marijuana episode. They had had forty fits when she told them she was pregnant and brought Gramm home. He had worn jeans with more hole than jean, had rings through his nose and ears, and his hair was at that time pink. Now it was purple. He had no job, and had never had one. He was certainly not intending to get one either. Gramm hated all that shit that society told you you should have. Gramm was a rebel. That really was why Lucy loved him.

But now Gramm had gone to live with some friends in a council flat. There wasn't enough room there for her and the baby. Besides, the baby was a bit of a drag when it came to partying in a small space like that, as Gramm had pointed out. The music kept it awake, and then it would start bawling, which was a real party pooper, as Gramm had it.

So Gramm told Lucy that he still loved her, and that she and the baby could drop around in the day occasionally. But not when they had taken magic mushroom tea, because he was inclined to get paranoid and not answer the door. Mushroom tea could make you see monsters, werewolves, or aliens. Lucy would have to find somewhere for her and the baby to live. Gramm said it would be easy. She must go on benefits and go to the council. Simple as. They would have to find her somewhere. He couldn't pay maintenance as he had no job.

Chard: so innocent by daylight. (*Silver Star*)

So Lucy had done this. The local authorities said there was a waiting list a mile long for council houses. Lucy had cried. The baby had cried. The lady from social services became involved. Eventually they got a cottage that was let out to the council for rental by a local farmer.

So it came to be that Lucy and baby Imogen, so named after Lucy's mother who would no longer speak to her, moved into the little, run-down terraced cottage in Chard. All the paint was peeling. The window frames were rotted. The inside walls had all been hurriedly painted over in matt magnolia. The skirting boards were rotted, with huge holes that looked like rat holes. Lucy shuddered and tried not to think about it.

Gramm and a couple of his friends helped to move Lucy's possessions. These consisted of a bed mattress to sleep on. Imogen's cot and pushchair, one rickety dining room chair, a bin liner with some of Lucy's clothes, another black bin liner with Imogen's nappies and clothes, a cardboard box with Imogen's toys, a kettle, and four chipped mugs. Lucy had managed to get a loan from the social services to get a sofa and a cooker. But that had not yet arrived.

Lucy made tea for all and gave Imogen a biscuit to keep her quiet. Gramm had brought them a pot of fish paste. He said that Lucy would enjoy it as posh people ate it at tea time, and her parents were posh, weren't they? But they couldn't have any as they had no bread. So they all had a cup of tea, and soon Gramm and friends left, wishing Lucy well in her new home, just as though Gramm had never been part of her life.

Imogen had fallen asleep in her pushchair. Lucy felt desolate as she shut the front door after her guests had left. The whole place had a fusty smell. It was a warmish autumnal

day, so she opened all of the windows downstairs. Then went upstairs to open the bedroom windows.

The stairs too had rot in the wood, and they were bare. There was a little landing window letting in some light. Light, unfortunately, was not all that it let in. Water had been seeping in through the rotting window frame, leaving a brown stain all down the wall. There was one stark light bulb with no light shade in the ceiling above the window.

Lucy turned left to the bathroom. The yellowed door was ajar. She went inside to find a dirty white bath crawling with woodlice and a brown and white limescale stain where the tap continually dripped. The hand basin fared no better. Rusty brown streaks fell away from underneath both taps. The toilet pan was dark brown at the bottom, with streaks of caramel running from the rim over the chipped white porcelain. The bathroom floor, like the rest of the house – save for a dirty and a rather smelly brown carpet in the sitting room and cracked old linoleum in the kitchen – was just badly laid concrete, cracked and paved with time.

Lucy's lovely white brow creased. Her fine brown eyes filled with tears. She angrily threw her long plait of dark hair back over her shoulder. So this was where she and Imogen must live? As Bette Davis had said in that film, 'Whhaat a dump!' That about summed it up.

She went into the stark bedroom. Rotting skirting boards to match the rest of the house, magnolia walls, rotting floorboards. The lonely mattress on the floor. About twenty dead flies on the windowsill. The panes grimy. She opened the window and looked out on a small garden. Rank grass, bindweed climbing everywhere, a withered rosebush trying to push out of the tangle, a few sickly yellow flowers blooming in the midst. A live fly buzzed, bumping against a dirty window pane.

Lucy went back onto the landing. Suddenly a chill ran through her. She shuddered. She remembered her grandmother's saying that feeling like this was as if someone had walked over your grave. She shivered some more. There was something about the landing that she did not like. It had a mournful feel. Heavy. Sad. Frightful. Lucy stood as if rooted to the spot. Little beads of perspiration broke out on her brow. Lucy was afraid, and she didn't know why.

The spell was broken by Imogen, who had begun to grizzle downstairs. 'Mumumumumum,' she said, in her baby way. Lucy ran down and took her daughter up into her arms. 'Whatever is it coming to, Imogen? What are we doing here?' The baby's hair became wet with her mother's tears.

Night came all too quickly. The darkness seemed to seep into the corners of the rooms in the house, despite all the naked bulbs. A cool breeze rustled the undergrowth in the garden. An owl hooted somewhere. A pale sickle moon hung in the sky. Imogen slept soundly enough in her cot in the bedroom where Lucy had set it up, next to her mattress on the floor.

Lucy, feeling jittery and lonely, sought out her transistor radio: a tiny thing, given by her parents on her tenth birthday. She fiddled with the knobs and tuned in to the first station she could. The reception in the house was poor, and the radio squeaked and jabbered, whistled and popped. Eventually she found a station playing music from the past. It was the sort of thing her mother and father had played at home after dinner guests had gone.

'Fly me to the moon...' crooned Frank Sinatra. She could see them now. Sometimes dancing. If they had had enough wine at dinner, they would be in close embrace, cheek to cheek. She could see the sixteenth-century cottage that was once her home. Chocolate box. Roses around the door. Thatched, leaded windows. Turkish rugs. Laura Ashley sofas. Clean,

bright, warm. Snuggled into the Somerset hillside in a sleepy village. Tears began to stream down Lucy's face. So this was what it brought, this love she had for Gramm? The loss of all of that?

She wanted to turn the radio off. To stop it from invoking such memories. But it was the only company she had, and so she declined. She decided to pull herself together. This nonsense must stop. Gramm would come back to them now. They could make the best of the cottage. She was sure that he loved her. And little Imogen. It was just a case of him growing up a little, that was all. He was used to being free. That was it. It always takes a little time for someone like Gramm to settle down. So she told herself.

Soon she realised how tired she felt. It had been quite a thing. This move. Tomorrow she would see Gramm and sort things out. She would only have to get through this one night alone. And she wasn't alone. Imogen was there. Beautiful Imogen. With her mother's dark hair and long dark lashes, and Gramm's vivid blue eyes. And her grandmother's name. A bright, pretty child.

Lucy climbed the stairs. She found herself running past the landing and into the toilet. Soon she was checking on Imogen, who truly looked like a little sleeping angel, a wisp of dark hair across a pink-tinged porcelain cheek. Lucy undressed, put on her pyjamas, lay on her mattress, pulled the duvet up under her chin, and was exhausted enough to soon be asleep.

At about 1 a.m. Imogen awoke, calling for her drink. She often did this. Her drink was in a baby's bottle. Lucy knew it was more for comfort than for want of liquid. But that was alright. Lucy's hand reached out in the darkness, feeling for the bottle, which she always kept at the side of the cot. Something ran over her hand in the dark. She shuddered, and quickly pulled her hand back under the duvet. She was afraid to think what it was. Then she realised that she had left the bottle downstairs in the kitchen. Imogen began to grizzle. Lucy lay in the dark and wondered why she was reluctant to move.

It was at that precise moment that she heard something moving on the landing. It was a sort of shuffling sound. Very like someone who is feeling dejected and cannot bother to lift each foot, but lets them drag in a shuffling gait.

Lucy lay in bed, petrified. Had someone broken in? She had not heard anything. She had firmly locked all of the doors downstairs. There were no windows open anywhere. The shuffling gait stopped outside the door. Lucy got quickly out of bed and took Imogen from her cot, and hugged her under the duvet. Imogen still grizzled on for her bottle. Lucy's heart was pounding; sweat had broken out all down the centre of her body, back and front. There was no lock on the door. Whoever it was could get in...

Lucy just lay there, waiting. What else could she do? She had no weapon. Imogen could not be comforted. She began to really cry. Lucy's throat, too dry with fear, would not let her pass one word of comfort to her baby daughter from her lips.

Then, as if in some kind of sympathy with Imogen, Lucy heard what could only be described as a desperate sort of wailing sound coming from behind the door. It was the sound of a heart breaking. The wailing carried on, with several pauses, and then there was a series of long sobs, so loud that it drowned out Imogen's baby voice. Imogen was not used to not being attended to.

Then there was a huge thump on the door, as if something or someone had flopped themselves down hard against the door. This made Lucy jump, and a piercing scream came out of her mouth involuntarily. This made Imogen cry louder, and this time, sensing her mother's fear, there was a tinge of terror in her own cry.

The terrible wailing began again outside of the door. Followed by sobs, and then long sighs. Lucy tried everything to comfort Imogen. She tried getting her to suck her finger. She tried talking gently to her. But Imogen was now bawling and red-faced. Lucy's shaking hands held onto her baby daughter, and she pulled the duvet up over their heads to shut out the dreadful noise on the other side of the door. It seemed to have increased in volume as Imogen bawled.

Lucy could not say how long this went on for. But eventually Imogen fell asleep in her arms, exhausted by her crying. Lucy just lay stiff with fear. Not even being able to get herself out of bed and turn on the light. Whatever it was on the other side of the door obviously had no intention of coming in. Or did it?

As the first few streaks of dawn came through the curtainless windows, the wailing trailed away to a last few sobs, then stopped. Lucy looked at Imogen, who was sleeping fitfully, one cheek too rosy and hot. She heard the shuffling gait, as though the thing was moving off. Lucy relaxed just a little, and found her body to be hurting all over due to the tensing of her muscles. She was still too afraid to get up. So she lay there looking up at the flyblown ceiling.

At around 5 a.m. Lucy got dressed, took Imogen in her arms, carried her downstairs, carefully not looking around too much on the landing as she passed, and put her in her pushchair. She ran out of the front door, and then made her way to Gramm's shared flat.

A bewildered and sleep-dazed young man answered the front door. 'What the... Oh, it's you! Lucy! I thought it was the pigs! Dawn raid!' She could see his hands were shaking. She pushed past him and got inside.

'Oh shit,' he said, suddenly, as if remembering something important. He looked furtive.

'Where's Gramm?' Lucy was wringing her hands in agitation, tears pricked her eyes. Imogen was sucking at her bottle sat in the pushchair, oblivious to her mother's night of terror.

'Um...' the young man began.

'Don't mess about Philip. Where is Gramm?' Lucy's voice was raised now to a pitch somewhere near to breaking glasses.

Lucy marched over to the bedroom door. This was the bedroom her and Gramm had shared. She threw open the door, just wanting to rush into Gramm's arms and be held. But to her astonishment Gramm wasn't alone on the mattress. A girl with spiky red pillar box hair was scrabbling to her feet. She had on one Lucy's lacy red nightdresses. She had long white legs, and pretty green eyes. Gramm just looked stunned; and stoned.

Lucy stormed out, tears pouring down her face, and grabbed the pushchair. She ran all the way back to the frightful cottage. Gramm had pulled on a pair of trousers and had run barefoot after her. She slammed the door in his face.

'Lucy! Lucy!' he was shouting through the letter box. 'She doesn't mean anything to me. Not like you. For God's sake let me in Lucy!'

Lucy opened a window and threw the pot of fish paste at him. Imogen was smiling and saying, 'Dadadadada.'

Eventually Gramm went away. Lucy could feel the tears welling up, and the most awful pain was ripping around in her solar plexus. Suddenly she let out a wail like the phantom on the stairs. She cried for about an hour as if her heart would surely break.

Then she pushed Imogen down to the nearest 'phone box and called her parents' house. Her mother answered the 'phone. 'Mummy...' Not mum, now – the baby terminology. She

The Guildhall in Chard – but the council has no jurisdiction over the realms of the dead...
(*Silver Star*)

needed a mother's comfort as she comforted her own baby in her arms. 'I've been so foolish. Can me and Imogen come home please?' Now she was sobbing along with Imogen.

Lucy never did know if the phantom that wailed on the landing was real, or whether it was just a part of herself.

The Knicker-Pinching Phantom
of Portishead

Joyce Chandler, a sprightly seventy-year-old woman, who never went anywhere without rearranging herself in the mirror several times, was very perplexed.

Her small, spick-and-span early Victorian house, usually such a pleasure to her, even though her husband had died just three years back, had become a nightmare.

She lived in Portishead. A little portside town on the edge of the Severn Estuary. Nowadays of course it was not a port, but a marina. Many changes, in many ways, had come about since she and her husband Leonard had bought the house back in 1947.

Leonard had been born in Portishead, and loved to go and watch the boats and walk the little pier and gaze out over the water. He was proud of his birthplace. Joyce was not so enamoured. Portishead being the birthplace also of that (as she thought) crude and drunken West Country warbler Adge Cutler. And, to her distress, people would always comment on that fact whenever she mentioned she lived in Portishead. And, worse still, quote bawdy lines from the songs at her: 'There's an ol' buck rabbit wi' a dirty habit up the clump!' Which always infuriated her. Especially as she believed that she had an 'image' to live up to in the town.

But now it was the 1990s and Leonard had passed on. She didn't really miss him that much. She would never have admitted this to anyone, perhaps not even herself, but she was rather relieved that he wasn't there in some ways. The house remained spotless without him there. No more grime left around the sink after he washed his soiled hands when he came in from the garden. No more muddy footprints on the kitchen floor. He had had such an annoying habit of forgetting to wipe his feet properly, or to take off his boots. And, worse still, he left dirty socks in the chairs, or in the cracks of the cushions of the sofa. He would switch on the TV to watch the horse racing or maybe a gardening programme, and would strip off his socks to get comfortable, and then leave them rolled up in the chair. It was, she thought, a disgusting habit. And one even her constant nagging never broke.

So now she lived in her pristine little house with no one to spoil it. She lived comfortably too, as Leonard had taken out good life insurance. She was, she imagined, a rock of respectability in the town. A member of the ladies' guild. A member of the women's

institute. And she always did the flowers for the church. How people would comment on her arrangements! And, better than this, as far as she was concerned, was a visit from the vicar every Friday afternoon for tea.

Friday afternoons were anticipated, and rehearsed, many times in front of the mirror. She would don different clothing, deciding whether the rose print tea dress or the silk Windsmoor blouse and skirt would be fitting. Her hair, still dyed a deep black, would be brushed around her face in a fashionable bob. She had even tried Botox. Why not? She saw herself as still very attractive. She was sure that the vicar, though twenty years her junior, found her so.

And it was a kind of pleasurable agony to decide which of the tea sets to use. Her glass-fronted Edwardian china cabinet was stuffed to the brim with Staffordshire bone china. And what a delight it was to see the vicar's delicate slim white fingers curling around her 'old roses' teacup. So much better, she thought, than seeing Leonard's common gnarled hands holding onto the delicate porcelain. And how he had slurped at the tea! Blowing on it first to cool it. How it had made her wince. She was quite afraid that he might drink it from the saucer next!

Fortunately she made sure that he only had ugly ordinary mugs most of the time. But when her sisters or her mother visited, she would have to get out a good tea set – not the very best of course, but a nice one. And then, much to her chagrin, she would have to allow Leonard a cup and saucer from the set as they all drank tea together. His slurping and sometimes his burping (God forbid!) were sneered upon by her family. Oh how she had married beneath herself!

But these days, with Leonard gone, she had no fear of such humiliation. Tea times had become a blissful ritual. Now she could telephone her sisters, and tell of the vicar's visits. Or the ladies from the guild. And what she had worn. And what china she had used. And whether the vicar preferred thin rich tea biscuits or bourbons with his Earl Grey tea.

But now this was changing. She sat on her bed with its pink quilted coverlet, and stared onto her walnut dressing table mirror. The face looking back at her did not look like her own. It was bare of make-up. Underneath the eyes looked puffy. The skin slightly doughy from the Botox. The neck looked course, ringed in folds. The dark brown eyes staring back held a kind of madness.

When it had first started, she thought that maybe she was suffering from memory relapse. Two ladies from the women's guild had visited. They had gone into the conservatory for tea. Joyce had set out the willow set with a plate of lemon puffs and rich tea fingers. They had commented on the conservatory furniture. Newly bought with Leonard's insurance money. They were impressed with the tea set, made circa 1940. They loved the house and the neat garden, now tended by a paid gardener. Joyce had put fresh roses on the table. And linen serviettes, not vulgar paper ones. Joyce was now sure that she was floating about six inches above the ground. Praise coming from the wife of a local councillor, and the wife of a bank manager, could have that effect. All that, and no fear of Leonard suddenly coming in whistling Adge Cutler tunes in that offensive way he had. And sometimes even daring to come into the room when she had guests, in dirty boots and trousers, and with his unshaven face and awry hair. Although mostly he did not dare, and made sure that he had on a clean shirt and had seen to his toilet. But his presence would still rankle her. He was, *had been* – she had to face it – just common.

It was when Joyce was feeling that she had wings on her feet that she noticed something on the arm of the chair that the bank manager's wife was sitting in. It was a pair of her

Portishead Marina. (*Silver Star*)

knickers. And not the pretty and expensive ones that she hung out on the line in the garden. But the everyday ones. The comfortable ones that could get a bit tatty. A bit faded. The ones that she always dried indoors so that no one would see. And horror of all horrors, the bank manager's wife had her arm rested on them, obviously oblivious to their presence!

Joyce's hand trembled slightly, making the cup rattle a little in the saucer, as she handed the two ladies more tea. Her mind became quicksilver. 'Ladies,' she trilled. 'Do come out in the garden and look at the roses. My late husband planted them, and they are so wonderful this year.'

A little dismayed, the two women followed her into the garden. And while they were admiring the blooms, Joyce scurried back into the conservatory and rescued the knickers.

That was the beginning of the nightmare for Joyce. The scrape with the bank manager's wife was not the end of it. Next came the most humiliating thing she felt she had ever suffered. And she was now afraid that either she was going mad or that some malicious entity was at work within her own home!

It had been a couple of months since the visit by the two women from the women's guild. It was late summer by now. The grass on the lawn was a little parched by lack of rain. The roses were over. But marigold and mallow still flowered. And the big pots of geranium so beloved of Leonard still blazed in reds and oranges and pinks on the patio.

This was a Friday, and the vicar was coming to tea to discuss the flowers to deck the church for the harvest thanksgiving. Joyce, having quite forgotten the incident with the knickers, putting it down to a little bit of forgetfulness on her part. After all, although she

considered herself to be young for her age, the mind could be a little more forgetful when one got older. Everyone knew that. So today she was all of a flutter.

She put on a pair of black tailored slacks and a Jaeger silk top in fuchsia. Looking at herself this way and that in the mirror, she decided against it. Too informal. Then she put on a mauve chiffon dress, sprinkles of violets in the pattern of the fabric. She looked in the mirror again. No. Too dressy for tea. Finally she decided on the pale green linen trousers and cream lace top from John Lewis. But first she had to put on the 'magic knickers' from Marks & Spencer to get her outline right.

It was then she remembered the terror of the guildswomen's visit and the knickers on the arm of the chair. She rushed downstairs and checked every chair and the sofa, and everything else she could think of, to make sure there was nothing untoward left about for the vicar's visit.

So when her doorbell rang that afternoon she was feeling confident. Her helmet of black hair sleek. Orange lipstick and a spot of rouge. And a little Dior Poison behind her ears. Her very best Staffordshire china was on the little table in the lounge, along with sugar cubes and iced biscuits.

It turned out to be a delightful afternoon. After the tea and biscuits they retired to the big soft sofa covered in floral chintz. Joyce sat close to the vicar with a notebook in hand while he looked through the album she had created of different flower arrangements, deciding on which ones to use this time in the church. Leonard had done all of the photography, which had been another of his hobbies.

The vicar sat back, and moved one of the scatter cushions to get more comfortable. And, as he picked it up, something wrapped around his hand. He lifted it out. It was a pair of knickers. The same faded, tatty knickers that Joyce had thrown away after the visit from the guild ladies. The very same ones! How could it be?

Joyce felt the fire in her face. It had spread all the way up from her bosom and now reddened her whole face. Her hands trembled. She could not speak. Her mouth had gone very dry.

The vicar made light of it. He put the knickers aside, mumbling something about dropped washing. Very soon after, he made his choice as to the flower arrangements and discreetly left.

After seeing him out, Joyce ran up to her bedroom. The face she saw in the mirror did not look like her own. The usually sleek black hair was awry. The lipstick was smudged on her mouth. And the wild eyes staring back certainly could not belong to her could they? She took a deep breath and tried to pull herself together. With trepidation she went back downstairs.

She gingerly pulled back the cushions on the sofa, like a woman who expected a tarantula to appear. The knickers had gone! In terror she threw all of the cushions onto the floor. There were no signs of the tatty underwear.

She ran back upstairs and searched through her underwear drawer. Silk and lace. A few nylon and cotton. But all new and in good order. Not a shabby pair of knickers in sight. Was she going mad? For a moment or two she felt terrified. Then she pulled herself together, and realised that perhaps the paranormal was at work. She was not a woman who believed in such things in normal circumstances. And then Leonard came into her mind. Why he should, she did not know. But he did.

The next day she called the vicar. She was very careful not to mention the knickers. She was absolutely sure that his voice sounded cooler than usual. She told him that she needed

help. That she felt there was a poltergeist or somesuch in the house. He asked if there was strange knockings or poppings, or objects moving around on their own. She said that objects moving certainly applied. She asked if he might do an exorcism and said that she felt very uneasy in the house now. Did he think it had anything to do with her dead husband?

The vicar could tell that her nerves were frayed. He told her kindly that exorcism was not in his repertoire. He said that some Catholic priests were expert at this. Did she want him to send one around? Of course the priest concerned would need to consult the bishop. Joyce was hesitant. She wasn't sure. Catholic priests worried her. They smelled like pagans – they used awful incense. And she was concerned about recent media stories concerning homosexuality within the orders. She wasn't sure if she wanted a gay exorcist. Leonard would not obey a gay priest. He had been homophobic in life, so he probably was in death. She voiced her concerns. The vicar discreetly made no comment.

Eventually she agreed. A date was set for the priest to visit. Somehow it got out into the local media. It caused quite a stir. Joyce had become the centre of attention. She started to enjoy herself. Well, it was an opportunity to wear all the wonderful new clothes bought by Leonard's insurance money after all. Her photograph appeared in the *Gazette*, with the headline 'Elderly Woman's Terrifying Poltergeist Ordeal'. She tried to get them to change the 'elderly' bit.

Soon the day came for the actual exorcism. Local reporters and photographers were on hand. Joyce, immaculate in Prada, preened as the priest did his work. He conducted his

Portishead again, 'dreary home-town' of trip-hop outfit Portishead. (*Silver Star*)

ceremony with such a theatrical flair that Joyce was a little troubled that her fears about Catholic priests were grounded. They finished by having their photograph taken together in the garden. Then it was all over, with promises that she would be troubled no more by any spirit or entity within her home.

On the day the *Gazette* plopped through her letter box Joyce was feeling on top of the world. She knew that the ladies' guild and the Women's Institute had been humming with her name and the story of the poltergeist. She looked forward with relish to the photograph of her with the priest in the *Gazette*. No one had ever seen the Prada before, it was brand new. She just knew that it would look a dream on her!

She did a ritual breakfast of pink grapefruit followed by a little Special K. How it had been worth it to preserve her figure! She poured herself Earl Grey from the everyday teapot, and settled down to look at the *Gazette*. Oh, she had made front page! There she was in the Prada. Oh yes, she did look good! And the priest... Yes, well, he did look a little gay. And the garden in the early autumn sunshine, late blooming roses and a few stargazer lilies in the foreground. Perfect.

Then her eye caught the washing line in the background, which should have blended in, being a green line. But to her horror, hung upon it, blowing in the breeze like a triumphant flag, was the foulest, baggiest pair of knickers that she could have ever imagined.

The Exmoor Murderer

In the late summer of 1965, Kathy Stanton and her family decided to go camping on Exmoor. Leaving their home in Chapmanslade one sunny afternoon, the whole family were excited by the prospect of their holiday.

The family consisted of Jim, Kathy's husband, Derek and Peter, their two teenage sons, and Joanne, their daughter, who was seven years old. They were not well-off so a camping holiday served them well. Anyway, they all enjoyed the outdoors, except for Kathy, who usually found it too uncomfortable after the first night of sleeping on the hard ground and would start to long for her bed at home. Neither did she relish the thoughts of wild animals at night, or marauding native ponies that were known to bite and kick.

But Kathy had come along anyway, not wishing to be a spoilsport. It was all they could afford and that was that. So for the children's sake she had better try to make the best of it. So they packed up all of their equipment in Derek's red and white Ford Consul. The Ford was Derek's pride and joy. His first year as apprentice on a building site had bought him the car. It was roomy, and had swish beige leather seats, and a fine array of dials on the cherrywood dashboard. It was he who drove them to their holiday destination.

The first thing they did when they had driven to the edge of Exmoor National Park was to stop in a country pub and have a ploughman's. This was on Derek. He loved to treat his family with his hard-earned pay. He had seen how his mother and father had struggled financially in the past. He was a conscientious young man. And he loved to spoil his little sister Joanne whenever he had the chance. Joanne had nearly died of whooping cough when she was four years old. It had broken all the family's hearts to see her suffer. She was a strange, 'fairy' child.

After they had finished their treat at the pub, which was much appreciated by all (especially Kathy, who cooked each day for the family with hardly a break) they drove on to their destination. Along the way they listened to Jim's anecdotes of the past, Peter's full instructions as to how they must erect the tent, and Joanne's excited exclamations at the shaggy little moorland ponies with their long manes and tails all tangled with burrs. Derek's jolly laugh filled the Ford, and only Kathy kept quiet, a slight discomfort in her stomach at the coming night in the tent.

They kept eyes peeled for a good campsite. In the '60s, one could camp just about anywhere. Occasionally a grumpy farmer might turn you off if it was private land. But more often than not a farmer would be helpful, selling you a few eggs for breakfast, or some milk. But today they were to camp on the moors. Peter had insisted on this. He had read about the moors and wanted to explore. Jim was always just happy to be outdoors. Derek was happy if his family was happy. And Joanne was a real child of nature – always at home where She was rampant. Only Kathy stood apart, recognising the beauty of the wild, yet not feeling entirely at home in it.

Eventually they all agreed to camp on the edge of a small, sparsely forested piece of moorland not far from Simonsbath. They parked the Ford on the edge of the small road that wound its way through the huge stretch of scrub, juniper and heather that made up the heathland. It was scorched russet and silvery blue by the sun.

A buzzard wheeled overhead and piped as they emerged from the Ford. Sheep bleated in the distance. A battered crow cawed on the wing. Kathy shuddered a little. The moors held a strange brooding silence, like some huge animal waiting to pounce. She looked at the others to see if they felt it. But Jim was away with Peter, staking out the ground for the tent, and looking for firewood. Derek was getting out the Primus and food box, and checking over the hurricane lamp. Joanne was stood looking out on the moors, 'Oldie' – the scruffy old teddy bear she had kept since she was a few months old – under her arm. Her face was rapturous. Her blue eyes gleaming. Her little thin legs danced under her blue checked shorts. Kathy felt suddenly alone.

Evening came upon them very quickly. The tent had been pitched, and Jim had lit a cheery fire, carefully guarded by a circle of stones, so as not to set the heathland alight. Derek had made a pot of stew on the Primus, and Jim had put some potatoes in foil in the hot embers of the fire bed. So they all ate a hearty supper with a good few bottles of beer to go around. Joanne scraped around her now empty tin plate with her spoon, and then asked for more. The fresh air was doing her the power of good. She had remained sickly after her illness – asthmatic and prone to chest infections. But today her cheeks had roses, her eyes were bright. Kathy wondered secretly how such a mournful place could produce such good health.

They all sat and watched a pale sickle moon rise. Shadows started to fall across the landscape. An owl hooted somewhere far off. Bats flitted and swooped around them, hunting for tiny insects, their wings black against the fading blue of the sky. A few strands of mist curled up from the brown soil, and a light dew appeared as the temperature went down a few degrees. Kathy shuddered despite her extra jumper. Jim was telling more stories around the fire. Derek was sitting next to him with a bottle in his hand. Peter was pouring over a map by the light of the hurricane lamp. Joanne was running happily in and out of the few trees, babbling on incessantly to Oldie, as was her wont. Kathy dreaded the night to come. She just knew that she would never get to sleep.

It was then that it came to her to sleep in the Ford. It would be so much more comfortable than in the tent. The wide seats would be a soft bed, with almost enough room to stretch out her legs. Much better than lying in her sleeping bag on the hard ground, listening to the loud snores of the men after too much beer. Safer too. No prowling wild animals. And warmer. Yes, that was it! What a wonderful idea! Kathy perked up incredibly. Now perhaps she would really enjoy the holiday. The nights when camping had always been a horror to her. Now, with Derek's new car, she had found a solace.

She went over to the fire and put it to Derek and Jim. Jim looked at her with incredulous eyes. She didn't want to sleep under the stars, as he called it? (The beer talking, Kathy

Exmoor: get out while you can! (*Silver Star*)

thought.) Derek said that it was fine by him. Peter, too absorbed in his maps, said nothing, not caring where his mother chose to sleep. Then she called Joanne over. She told the little girl that she was to sleep with mummy in the car where it was warm and safe. Much to Kathy's dismay Joanne burst into tears, saying that she and Oldie wanted to sleep in the tent. Eventually, with promises of reading her stories about Narnia, Joanne agreed to sleep in the car too.

So, at around 10.30 p.m., Kathy and Joanne snuggled themselves up in the Ford; each with a sleeping bag. Kathy was on the sofa-like long seat at the front, and Joanne on the back seat where it was less likely she might accidentally hit any of the levers in the car while sleeping. Kathy put on the little light in the car roof to read a favourite book to an already overtired Joanne, as promised.

When they got to the bit in *The Lion, the Witch and the Wardrobe* where Lucy meets Mr Tumnus in the woods as the snowflakes fall softly and silently around them, Joanne's eyes drooped, and soon she was fast asleep, clasping Oldie to her bosom. Kathy looked at her sleeping daughter, at her tiny elfin face and her shock of dark hair falling from her white untroubled brow, and she smiled. How she did love these pretend worlds, this child. She would even insist she had been to Narnia herself, such was her imagination.

Then Kathy remembered Derek's only cautious words about sleeping in the car. He had said not to keep the light on too long as it might run the battery flat. So Kathy hurriedly

turned it off, and settled down to rest. Before long she was sound asleep too, tired from the travelling and all that fresh air. She slept restfully, in the knowledge that she was safe and comfortable in the Ford, Joanne along with her. The men were only a few yards away in the tent.

She had been asleep a couple of hours when something woke her. She lay there in the darkness trying to orientate herself. It took a few moments before she realised just where she was. She could see through the windscreen of the Ford that a thick fog had descended, as so often happens on the moors. For some reason she had a prickling sensation at the base of her skull that filled her with apprehension.

She looked suddenly at the back seat, dreading that Joanne would not be there. But she was. Her daughter was sleeping peacefully, her breathing even, dark lashes against a rosy cheek. Kathy held her two hands together, as if in prayer, against her mouth. Her heart was pounding in her ears. Whatever had woken her was unwelcome.

A light perspiration had broken out on the bridge of her nose and between her breasts. She stared out at the fog. It enveloped the car, and she could see nothing of the outside world. She desperately wanted to turn on the car light, but feared to wake Joanne. Besides, she did not want to run the battery down. Moments that seemed like hours passed. Kathy's eyes hurt from peering into the fog. Her heart still beating a tattoo.

It was then she realised that there was someone out there – or some*thing*. It was not that she could see anything at all. But she could *feel* it. She just knew that she could feel it...

Her mouth had gone dry, making swallowing difficult. She felt rooted to the spot. Thoughts of running across to the boys were cancelled out by the sheer terror of getting out of the car and of leaving her daughter.

She held her wristwatch close to her eyes. She could just make out the time. It was 1 a.m. She sat in a state of terror, hardly moving a muscle, hardly daring to breathe. She watched and listened, but the fog was still so thick there was no visibility, even within a foot of the car. No sound came either. It was as if the blanket of fog had silenced everything.

She was frozen in horror. When she looked at her watch again she realised why her body was aching so much. It was 2.05 a.m. She had been sat solid in the same position for over an hour! It was just when she was telling herself that it must have been a dream that startled her; or just her own imagination, that something happened that sent her heart leaping so that she felt it might jump out of her body. There was a loud knock upon the side window, right next to her.

An involuntary scream escaped her lips. It was echoed by a smaller scream from Joanne, whom she had wakened. Kathy sat immobile, her teeth clamped over her bottom lip. There was no doubt about it now. *There was someone outside the car.* Breathing rapidly, she tried to make up her mind. Joanne was sleepily asking if mummy had been dreaming, seeming to recover momentarily from her awakening. She sat up, clutching Oldie, and looked around to orientate herself.

Kathy, panicking, suddenly realised that the doors of the car were unlocked. Her hand shot forward like a striking serpent pushing down all of the locks. She took some deep breaths, trying to gain equilibrium. Perspiration stood out on her forehead. She knew that she must not frighten the child. She considered shouting for help, hoping that the men might hear and come. But they were a reasonable distance away, sleeping heavily after beer and a good supper. And shouting for help would certainly terrify Joanne, so what next? She looked down on her trembling hands, trying to decide.

A flock of sheep broods on Exmoor. Spectral murderers absent from this shot. (*Silver Star*)

She stared through the windscreen until her eyes hurt. But the fog was so thick that she could see nothing at all except for the wraiths that swirled against the car windows, leaving droplets upon the pane.

Then Joanne's small voice spoke out in the darkness. 'Mummy, a man is looking in through the window.' Oddly there was no fear in her voice. Kathy slowly turned her head in dread. And, through the back side window she could see a face peering in. It was a haggard, bearded face with pale blue eyes, framed by straggling white hair. The eyes seemed to hold a kind of gleaming madness. They peered in at Joanne on the back seat of the car. Kathy thought immediately of escaped lunatics.

It was then, to her horror, that Kathy saw that Joanne had the window half down, as she always liked air circulating while she was asleep. As quietly as she could, and trying to keep her voice level, Kathy said, 'Jo sweetheart, wind the window up for mummy.'

But before Joanne could reach for the handle, a hand appeared through the gap in the window. It was a grimy hand, with long fingers ending in broken and dirt-ingrained nails. The man was there again, face near to the open window, staring in at Joanne, wisps of white hair falling in straggling locks as he bent in.

Kathy actually thought that she was about to faint. Her hands clawed at the leather seat as she tried to remain conscious, her body rigid with fear at the thought of her small daughter being at the mercy of this intruder.

Then a strange thing happened. Joanne, whose voice appeared perfectly normal, as if she was completely unfazed by the experience, said, 'Don't worry mummy. He has talked to me.

He is just looking for his little girl. He did a bad thing many years ago.'

Kathy, gaining a little composure now, looked back at her daughter. There was no sign of the man. Joanne was still clutching Oldie in her arms. She showed no signs of fear.

'But darling,' said Kathy, 'I didn't hear anyone speak, including you. Please shut that window immediately!'

Joanne obeyed her mother. 'No. He spoke to me in my head. And that is how I spoke back to him.'

Kathy, looking around, heart pounding, told Joanne to get out of the car. Then together they raced through the fog to where the tent was. Then Kathy woke the boys and told them the whole thing. Kathy was now near to collapse. But Joanne remained calm and reiterated her own story. Jim was beside himself with worry. Derek and his father ran out into the fog and searched around. Soon they re-appeared, saying that they had found nothing. They decided that they would all sit together in the car for the rest of the night for safety's sake.

Soon dawn slid in, and with the rising sun the fog cleared and the sun burst through with the makings of a lovely late summer's day, brightening the moors, making them almost cheerful. Nothing else untoward had happened in the night. Jim cheered up and suggested that perhaps Kathy had been dreaming. This made Kathy angry and she decided that she wanted to go home. The child kept on telling them that she had spoken to the man. He wasn't a real man at all, she said; he was a ghost.

This was enough for everybody. It had certainly ruined their holiday. When they got back home Peter looked up some books that he had about Exmoor, and was astonished to find that there was a story of a father murdering his little girl and putting her body in a mineshaft not far from where they had camped. He told everyone the story. When he had finished Joanne looked up from where she had been playing on the floor and said, 'Yes. He was the man. He did a bad thing. I told you that.'

The Drummer of Burrow Mump

Burrow Mump is an extraordinary natural hill of Triassic sandstone. On its summit is a ruined church thought to be built in the mid-fifteenth century in reverence to St Michael, as was the tower on Glastonbury Tor, which is visible from the mump summit. Excavation suggests that there may have been a building on Burrow Mump as early as the twelfth century.

It is a place of astonishing beauty, giving breathtaking views of the Somerset Levels, where rare wading birds call and the singular swallowtail butterfly can still be seen in late summer. The landscape is now farmland, with the King's Sedgemoor Drain running through it. It is still marshy in places, despite the drainage. It sits between two rivers, the Tone and the Cary, which join the famous Parret. Willow grows in abundance, and goods of various sorts are still woven there from the malleable willow wands.

When pictured from the air it looks for all the world like a woman's breast, the ruined tower on top the nipple. Many people have speculated that it lies on a ley line, along with Glastonbury Tor. It has definitely a magical feel to it, and was obviously thought important enough by some to become a place of memorial for those soldiers lost in the First and Second World Wars.

It is unsurprising to find that many people visit the mump. In September 1998, Calvin Shooter, his partner, Maddy, and their small son, Edward, decided to break their journey on the way home from a holiday in North Cornwall by camping on the mump.

They had not heard of the mump before, even though they knew Glastonbury well. So when they traversed the main Bridgewater road on their way home and caught sight of it, Maddy insisted they stop and take a look. Maddy was a tall, slim young woman in her thirties, with long dark hair falling to her waist and blue-green eyes. She was a romantic at heart, and loved these places. She thought they belonged to Faery. Calvin was tall and slim too, dark-haired and -eyed. But Calvin had a more practical mind. He loved archaeology and geology, she earth energies and geomancy. Edward was a wispy, long-legged child, dark of hair like his parents and hazel-eyed. He had his father's curious mind and his mother's psychic perceptions.

The 'nipple' of Burrow Mump. (*Silver Star*)

After they had all explored a little, and had been right to the top of the hill and admired the stunning view of the beautiful Somerset Levels, Calvin set up their little gas camping cooker and soon had bacon sizzling in the pan. It was a warm afternoon, and after eating bacon sandwiches washed down with liberal amounts of good strong Assam, Calvin set up the small tent all three would soon be sharing for the night. Maddy sunbathed dreamily on the grass, and Edward, his spring-coiled energy not yet depleted, was running up and down the hill, with Mavis the diesel engine from the Thomas series firmly gripped in his hand.

Soon the sun had moved well over to the west, and there crept in a little chill on the evening air. Maddy reached for jumpers for both her and Edward. By 8 p.m. the shadows were falling, and Maddy could hear the slightly eerie sound as a gentle wind whistled through the broken tower of the church on the summit of the hill.

Maddy lit the little stove and made a cup of chocolate for all. This was gratefully received by Edward, who also had a bowl of cereal before settling in his sleeping bag to sleep in the tent. He was now quite exhausted, what with the travelling and his healthy jaunts up and down the hill. Calvin was atop the hill looking closely at the ruins, and doing measurements in his head as to its original size. Maddy knew that his chocolate would be quite cold before he would come down to drink it. So she tucked Edward in, read him a Thomas story, and soon found out that his little eyes had closed long before the story's ending. His arms and legs were thrown apart.

It was nearly dark by the time Calvin came down to join his wife. The wind had dropped, and he found Maddy sat, legs curled beneath her, a little way from the tent, staring down at

The Somerset Levels, as seen from the mump. (*Silver Star*)

a few brown and white bullocks grazing contentedly in the next field. He ignored the cold chocolate and pulled a cap off a bottle of Speckled Hen. He took a sip then handed the bottle to Maddy.

Maddy took a sip and sighed, 'Oh I would love to live right here.'

Calvin laughed. Maddy always said this in places she loved. That meant she would be living in about 200 places! He began to tell her about his speculations regarding the church ruins. And so they sat, hand in hand, sipping at the shared beer; both content.

Soon they both noticed that a mist was creeping up from the levels. It had come quite suddenly, and at first made a flimsy veil over the landscape. But soon, as the mist slunk up on them, they could not see the cattle in the next field. They both had dew drops over their hair and clothes, and little droplets ran from the blue tent material in small streams. Calvin exclaimed at its rapid onset. Maddy sat mesmerised by its beauty, despite being damp.

It was when the mists had become so thick that it was difficult for them to see one another that it started. From somewhere far below them, out on the levels, came the sound of a drum. It was not low and sonorous, as a big drum might have made, but high, tapping, as in pipe and drum. A rolling beat, followed by a rat-a-tat-tat. The acoustics of the land were such that it was a loud beat. Both Calvin and Maddy heard it plainly enough. Both were very unsure where it could have come from. It was a sound from the past. A phantom drummer still walking the levels after the battle of Sedgemoor. Maddy said as much. It sent a shiver down her spine. They were sat, visibility nil, on a strange mound in the heart of Somerset

The mump's ruined church guards its secrets closely. (*Silver Star*)

as the mists seemed to curl around them, a cold chill blanket embracing them and blinding them. Maddy squeezed Calvin's hand so tightly that it made him yelp.

They really did not know afterwards how long they had sat like that, peering into the impenetrable mist, listening for the drum, hardly believing their own senses. Both knowing that they had definitely heard the beat from where there was nothing for miles but livestock and landscape and wildlife, save for a few houses dotted in the distance. No one and nothing that could have made that sound. Even Calvin could not come up with a logical explanation; he had to admit this. Maddy felt that she already knew the answer. Her mind was filled with a lonely drummer, a ghostly shade, still walking the earth and drumming forlornly about a battle that could not be won, so many slaughtered in the process of trying. She prayed that his earthbound spirit would be set free.

The Wild Hunt of Cadbury Castle

At the end of April 2001, Paul found himself on his way to Somerset from Wiltshire. He was to meet up with friends, who had decided to go on a 'witch hunt'.

This had come about after a night out at Avebury stone circle. It was the Summer Solstice, and Howey, Alex, Simon, Ian and himself had all been having a beer and a chat long into the wee hours. The young men decided that most of the people frequenting the Neolithic stone circle that night were nuts.

There was no doubt as to the ambience of the place. But with fire eaters, drummers, and people dressed up in velvets and silks of many colours, there *would* be ambience wouldn't there? Not to mention the wafts of dope smoke, the alcoholic beverages of various sorts, and other drugs freely snorted and ingested. It definitely added something, didn't it?

So what with that, and the chance meeting with a young woman who called herself Holly and claimed to be a witch, they decided, after much humorous debate, to go on a witch hunt. Holly had provoked them all that night by declaring that she was a child of Artemis, and that witches were practising magic today, as they always had in the past. She claimed that it was all real. That spells worked. That curses could be done. That weather could be controlled. Animals could be bewitched into good behaviour. Infertile people made fertile again. The sick healed.

How the boys had laughed at her, this bright young woman in her black velvet dress. Long, black hair, obviously dyed, but entrancing nonetheless, against pale skin and wide blue eyes. Of course they got even more interested when she said that all of the rites were carried out skyclad, by both men and women. Holly cared nothing for their cynical and piss-taking response. She stuck by what she had said and would not bend one inch. What she had told them was *not* lies, or even imagination; it was real. Very real.

And so, when the sun rose that summer morning, and the Druids' horn could be heard over the land, calling up the sun, a gaggle of rather hungover young men decided to go on a witch hunt. (Though whoever did they think they were, these Druids, to think that they had the power to call up the sun? So Holly had said.)

Paul could not remember whose idea it had been. But it was decided nonetheless. It had been feckless Holly who had put them on the trail of witches at Cadbury Castle in Somerset. Witches my arse, thought Howey. And Alex, Paul, Ian and Simon agreed.

They would go to this Cadbury Castle on Walpurgis Night the next spring (echoes of *Dracula*, 'another piece of bullshit written by a gay', according to Ian), and spy on these 'witches'. They avoided mention of the naked rites, and that there might be a degree of voyeurism in their pursuit of magical fraud. Well, they would, wouldn't they?

And so it came to be that Paul, being at the ancient hill fort first, parked his mother's Astra in the little car park at its base before climbing the steep hill that led to Cadbury Castle. As he got out of the car in the late afternoon in the fertile spring light, even he had to admit the breathtaking beauty of the landscape and the feeling of ancient activity.

Soon Paul's long legs were being stretched as they climbed the steep pathway to the south of the hill. He had a backpack containing his sleeping bag, many beers and some sandwiches, and a red baseball cap rested on his dark curls. He was young, muscular and fit, and would not let the hill take anything from his stride. He thought about Cadbury Castle as he climbed. He had researched the place a little; he liked history.

There had been settlements there as far back as 3000 BC. It had been attacked by the Romans at some point, as Roman weaponry had been found there on excavation. Then it had been re-occupied after the Roman invasion. That was when the fairy stories began, apparently. People whispered that it was the real Camelot – the court of King Arthur. Was there not a village nearby called Queen Camel? The name Cadbury was thought to have maybe been derived from Cador. Cador was a mythical Duke of Cornwall, who was the son of Gorlais and the beautiful Ingraine. This made Cador half-brother to King Arthur, and also half-brother to a fairy enchantress, the famous Morgan le Fay. The castle has a feasting hall, built of timbers on the summit of the fort, a place where important people might discuss significant issues. A place to put a round table?

Paul did not know about any of that. He was a person who liked hard evidence. But he was not insensitive, and could see why such legends might grow up around such a place as Cadbury Castle. When he reached the summit, 153 metres above sea level, he saw a view of unspoiled splendour. He could certainly see the attraction that it might have held over the ages. Green fields full of various livestock met his eyes, far into the distance. Slow yellow cows and white-wooled, black-faced sheep grazed. Some of the cows contentedly lay down, chewing the cud, their short stocky legs tucked under them, eyes liquid brown and placid.

The afternoon was spring warm, with a young sun and delicious pale yellow light. The emerald grass was sprinkled with daisies and buttercups. Lone crows flew overhead and occasionally cawed. Rabbits ran, showing off white scuts in their retreat. The azure sky had a few cottontail clouds floating towards the sun. Paul sat down for a rest after his climb and pulled off a cap to swig the golden beer. He could smell the sensual earth, warmed by the youthful summer sun. This place held the magic of nature, that was for sure.

Paul looked at his watch. The others had said meet at 4 p.m. It was now 4.32 p.m. Trust them to be late! Perhaps they were waiting for Simon, who would have needed to have left work at WH Smith early? Or perhaps Howey had had to help his dad with some grisly service or other?

Howey's dad was a gamekeeper and they ate a lot of the rabbits and suchlike that he had shot. Howey liked to murder things too. He'd been brought up to it after all. Paul had gone shooting with them before, but found he did not have the stomach for it, much to Howey's

Cadbury: the perfect spot for a little witchcraft? (*Silver Star*)

dad's delight. Now every time he saw Paul he would make snide remarks as to his lack of prowess. Howey's dad, brought up in conditions of Dickensian deprivation and downright sadism obviously did not think you were a real man if you did not go about abusing spouses and children and killing animals. It was a twisted view of manhood that Paul found too difficult to share.

At precisely 4.55 p.m. Paul saw a figure coming towards him in combat trousers and jacket. Howey. No signs of the other boys at all. Howey came running across as soon as he recognised Paul.

'Others aren't coming,' he said, breathlessly. 'Chickened out I reckon. Look at all them rabbits! Wish I'd brought a gun. We could have us a spit roast rabbit!'

Damn, thought Paul. He liked Howey well enough. After all, it wasn't Howey's fault that his upbringing had flawed his character, but to spend a whole night with him might get tedious … Still, they were here now. So witch hunt they must.

'This is some place though innit?' Howey threw down his backpack and got out a beer.

'It sure is,' answered Paul.

'Plenny fallen wood for a fire later and all,' said Howey, scanning the surrounding trees with his pale green-yellow eyes. He had taken the khaki baseball cap from his head. Perspiration sparkled on the blond stubble of his scalp. He was shorter than Paul by a good four inches, but wider, more stocky.

'Yeah a fire would be good,' said Paul. 'I expect it will get a little chilly tonight.'

Is the Wild Hunt coming? (*Silver Star*)

'What you reckon then?' asked Howey, finishing off his beer in one long gulp. 'Will them witches turn up?' He was laughing. 'Do you think they even exist? Or do you think that girl was havin' us on?'

'Dunno,' said Paul. 'I do know there are some nutty people here in Britain, and worldwide come to that, who consider themselves to be witches. Wiccans I think they call themselves.'

'Oh yeah?' said Howey. 'Reckon they been carried away with all that Hoggwarts stuff don't you?

'Hogwash more like,' quipped Paul. They both laughed. But Paul felt a strange feeling in the solar plexus area. A tickle. A niggle. A feeling of something impending. Of course he did not mention this to Howey. He also did not say that his research work had made him think hard about the existence of witches and the magical arts.

'What's this night supposed to be about? I mean, what do the nutters think is so special about tonight?' asked Howey. He looked jittery, as if he did pick up something of Paul's thoughts after all. His voice held a little too much bravado in it.

'May Eve. Beltaine I think they call it. I looked it up.'

'Getting to be a right little bookworm you are!' Howey punched Paul's upper arm playfully, but with force.

'Yeah.' Paul grimaced, rubbing his arm. 'Apparently in the old days there was a May Eve festival where couples got merry on plenty of food and drink, and then went off into the woods together to do you know what.'

'Now that sounds more like it don't it?' grinned Howey. 'Pity that little bitch Holly weren't here eh? We could share it. Not bad was it?'

Paul just smiled as best he could. It was always a little disconcerting how Howey would talk about women. No wonder Howey had no girlfriend.

'It is also Walpurgis Night. Transylvanian horror night! Well, it is said that evil spirits appear this night. So I hope you have worn your crucifix!' said Paul.

'Ha! I'd wear it upside down if I did.' replied Howey. 'Load of old bollocks!'

They spent a pleasant enough evening. And when the sun went down they lit a fire with the wood they had collected while it was still light. Howey had brought some bacon, and they cooked it on sticks and gratefully ate it between doorsteps of bread, also brought by Howey. Paul had to give him that. Howey knew how to live outdoors.

They had the place to themselves as dusk fell silently, casting shadows on the land. And by the time a gibbous moon had risen brightly in the sky, the last of the few dog walkers disappeared back down the hill. Paul got his fleece jacket from his backpack and opened a big vacuum flask of coffee. Real coffee. Strong and sweet with brown sugar. He sipped it gratefully, offering some to Howey. He realised he'd been shivering. But the temperature had only dropped a little. The smell of the coffee hung pleasantly on the air.

The whole place looked different somehow now that it was getting dark. It took on a strange fairy light. Uncanny. Preternatural. An owl screeched somewhere nearby. A badger bumbled along its ancient terraced route. To cast off his uneasiness Paul lit his hurricane lamp, and asked Howey if he wanted to play a game of cards. Howey, feeling the same thing, but certainly saying nothing, gladly agreed.

They played cards and drank beer, and had somehow fallen asleep by the campfire. Paul woke first, startled by a noise. It might have been the crack of a stick, trodden on by something – someone. He got up, stiff from the hard ground. The fire had died to embers, grey flecked with red. In the half moonlight Paul could see Howey lying on his side, in the foetus position, still asleep, a beer bottle next to him. He looked around and could see very little except the outline of the hilltop, carved against the sky, as if cut from cardboard. As he stared he could swear that he had seen some shadowy figures moving quickly along the top, and then, just as speedily, disappearing from view. They looked to be wearing some sort of robes with cowls, rather like monks' habits.

Ah ha! The witches have arrived then, thought Paul. Perhaps Holly told the truth after all. He bent and gently gave Howey a shake, grabbing his shoulder. 'Get up! I think our witches are here!' he whispered hoarsely.

Howey fingered his eyes and was up on his feet in a trice. The hunter was aroused in him. 'Let's stalk 'em,' he whispered back, grinning.

The adrenalin flowed as both young men set off after their quarry. The gibbous moon afforded them some light. But they could not penetrate the shadowy landscape very far with their naked eye. The hilltop seemed coated in a silvery gleam as they reached it. There was no sign of anything or anyone. All was silent. Even the owl had stopped screeching in the distance.

They stealthily crept towards a wooded area just off the summit. Howey insisted they crawl as if in combat. They lay flat on their bellies, hearts pounding, peering over the edge into the trees. But they could neither see nor hear a soul. It was hard to tell how long they waited there. But Paul's left leg had contracted pins and needles. He wanted to move. Eventually Howey stood up.

'Reckon you was mistaken mate. No one up here at all,' he said, lighting up a cigarette. But there was a hush to his voice.

'I saw something. But God knows where they went,' replied Paul.

It was then that something burst out of the trees, making a sound like thunder, like some quarry no longer quarry, but a hunter on the attack. An involuntary shout came out of Paul's mouth. A noise, rather than a word. Howey began to run. Paul followed quickly on his heels.

They ran down the slope past the campfire, past their backpacks and sleeping bags, right into a small copse of trees on the other side of the hill.

'It's horses and dogs!' gasped Howey. 'It's a fucking hunt! And it's after us!'

'What? How? This time of night?' Paul was totally confused and panting.

'Dunno about what or how. Just know it is. I saw them, horses and dogs with riders. Listen!'

A fearful baying rang out through the night. And the sound of thundering hooves was far too close for comfort.

'I tell you this,' said Howey, the sweat running from his brow now, running into his eyes. 'That is no ordinary hunt.' And with this he set out running again. This time out into the open towards where the hill dipped into the lane that led out of the hill fort. He was running for his life. 'Come on!' he shouted back to Paul.

Paul, his legs turned to jelly, could not follow. And with terror he saw a group of about

Not a lot – but was it once Camelot? (*Silver Star*)

nine riders appear up on the summit, outlined against the sky. A pack of hounds milled at the horses' feet. The leader of the group, sat upon a thickset pony, wore antlers upon his head. They sighted Howey and set their horses after him; the hounds bayed and ran on ahead. Paul screamed, and felt that he might lose consciousness.

Paul did not know how long it took him to recover himself enough to try to find Howey. The moon was setting in the sky. All was silent. A bird disturbed by him flew up, flapping, making him squawk with fright. Oh God, he was really afraid now. What if Howey was dead? What if that Devil's crew came back for him? Surely this was a dream? It could not be real. Surely in a minute he would wake up? He stood trembling against a tree, but his legs would not obey him. He was unable to move.

Eventually he could walk. The descent from the hill seemed to take an age. Paul was still trembling all over. He could not stop looking behind him, peering into the darkness with fearful eyes. He tripped and nearly fell, crying out as he did so. Tears welled in his eyes. His courage was at its lowest ebb.

Then, in the pallid moonlight, he saw a recumbent figure huddled on the dewy grass, at the top of the lane. His heart missed a beat. He could tell that it was Howey. He visualised a body bloody with terrible wounds made by the slashing teeth of giant hounds. He had seen a fox torn apart once by hounds. It was not a pretty sight. All blood and guts. Was Howey in the same state? He feared to go any nearer to look. He froze.

Then a sound emerged from the hunched figure. It was a sob. An enormous sob. The sound freed Paul's legs. Soon he was running towards his friend, and held him in his arms.

'Oh my God! Oh my God! Are you OK?' Paul found himself to be sobbing too. Tears trickled down his cheeks. Tears of relief.

Howey was shaking in his arms. He spoke at last, 'I am not hurt,' he croaked. 'But do you know what that fucker said?' He was crying now, like a baby.

Paul instinctively knew that Howey meant the leader of the hunt. 'What did he say? He spoke to you? Was he real?'

'He seemed real to me. But I don't know. I don't know.' Howey sat up and wiped his nose on his sleeve. 'He said, "Now *you* know what it feels like to be hunted, don't you?" That is what he said to me.'

The Luftwaffe Officer of Hengrove Park

Bill Shiles and his wife Milly lived in little tidy house in Oatlands Avenue, not far from Hengrove Park in south Bristol. Both were natives to the city. Both, now retired, enjoyed the bliss of not having to be early risers anymore. Bill had worked for forty-five years as a forklift driver in a warehouse. Milly had worked in a bakery shop. It was not uncommon, when still working, for them to have to be up at five in the morning.

Now they enjoyed a more sedate life. They had been prudent with their money, and, despite having reared three happy children, had managed to save a little nest egg for their old age. So they found themselves with an easier life in the 1980s than they had ever had before.

They celebrated this by buying themselves a little Blenheim Cavalier King Charles Spaniel. They called him Jimmy. Jimmy was a delight to them, with his handsome red and white silky coat, which Milly faithfully brushed and combed every single day. Milly also cooked up dainties for him to eat. Chicken liver, chicken breast, a poached piece of fish – Jimmy ate like a king. But best of all, as far as Milly was concerned, Jimmy kept Bill healthy. Bill would walk Jimmy several times a day, and, at night before bed, they would both go and walk him on the edge of Hengrove Park.

This kept Bill away from his constant pouring over old books about the Second World War. Bill had served in the army during the war, and had lost comrades and loved ones. Bill loved to reminisce and read about the battles and political strategies. This sometimes drove Milly to distraction. Milly was a here-and-now person. She lived for the present. She believed it to be the only way to true happiness. The past could hold some demons, the future even greater ones, especially once you had reached a certain age. The present was best. And she meant for the present to go on being good. Keeping Bill from too much sitting down and reading was one of the ways of keeping the present good.

Bill had been her first love, and her last, as the song went. He had only had one girlfriend before her. They came from an age when working class people were like that. The upper classes always played around, everyone knew that. The working class had morals and were fiercely proud of it. It did not occur to them that they might be missing out on some of the fun. Or maybe it was just that they lacked sexual education, and intimacy usually brought

What dark spirits frequent Hengrove Park when the sun goes down? (*Silver Star*)

with it a baby. It might have been that they feared for their souls if they sinned. Methodism, Evangelism, Catholicism, Church of England, whatever – they all taught you that you must not fall into the snare of the sins of the flesh.

Luckily Milly had no such religious leanings, and had simply fallen in love with Bill, and had never fallen out again. It had, of course, changed over the years. Passion had turned into companionship, which often happens to longstanding relationships. But Milly prided herself that she and Bill did not nag at one another, or dislike one another, or rub each other up, as so many other couples seemed to do.

She put this down to the fact that they had always tried their hardest to be a family. They had worked together as a team, facing everything together, good and bad. Of course they had argued at times. Couples lied if they said they never argued, according to Milly. They had had their share of ups and downs. Money worries. Worries over the kids. Health worries, though, thank God, these had been minor and few. And the time when Bill had kissed another woman under the mistletoe at a Christmas party. A misdemeanour that Milly would not let him forget; nor would she forget. She knew that she must stamp hard on this. It was, in her mind, infidelity, which was the true death knell of any relationship. Once done, never forgotten.

Yes, Milly knew couples to whom it had happened. It had happened to her close friend Jane. Jane had said forgive and forget. But Milly knew Jane never did forgive or forget. People don't. Not really. The affair, no matter how foolish, somehow breaks that invisible bond that man and wife build on an astral level. Something even greater than trust is severed, and cannot be repaired. Milly didn't really understand these things. She just felt them.

It was a blustery day in November, Bill's birthday in fact. The children had come around for tea. Milly had made plates of sandwiches, sausage rolls, and tuna and mayonnaise vol-au-vents; Bill's favourites. She had made a light sponge birthday cake with jam and buttercream and candles.

Jimmy missed his outing that day, what with the preparations and the visitors. Not that he minded too much. Sausage rolls came his way, and his very own piece of cake on a

saucer, which he ate daintily, but with relish. The house had been quite a-buzz: children and grandchildren, laughing, talking, tantrums and toys. Even Milly's head was quite dizzy from it all. She and Bill enjoyed every minute of it, but when the last plate had been washed up, and the visitors all gone, they had to admit that the silence was a balm.

'Well,' said Bill, 'our poor old Jimmy will need a walk and a widdle.' He got up and looked out of the window. It was now quite dark, and a steady fine rain was coming down. The wind had dropped somewhat, but occasional gusts rocked the branches of the trees.

'I'll come with you,' said Milly, getting up and reaching for her raincoat, hung up on its hook. 'I could do with blowin' the cobwebs away. We've been indoors all day.'

Jimmy was barking now, and running around frantically, while looking up to where his lead was hanging. Bill bent and hooked the lead to his collar.

When they were outside and had locked the front door, Bill turned to Milly and kissed her on the lips. 'I've had a lovely day, love. You do a smashin' cake. And I hope some of them vol-au-vents are left...'

Milly smiled as she bowed her head into the little gusts of rain-filled wind. 'I put a few in the fridge out of the way. I knew you'd want some later.'

And so they headed off together towards Hengrove Park. Hengrove Park is a seventy-six-hectare former airfield, now a recreation ground and sports centre. It was their wont to walk their little dog there, as it is for many dog walkers in the area. Milly and Bill loved it. They particularly loved the piece of overgrown land full of hedge sparrows, finches, tits and even a song thrush or two. Rabbits scurried like brown explosions whenever people appeared. Occasional larks rose and sang in the summer. And in the winter owls hooted and hunted and appeared like floating white ghosts in the night, eyes like saucers. A welcome piece of nature in the city.

Tonight they walked along, arm in arm, Jimmy straining at the leash. The rain eased a little as they reached their destination. The sky was a dark murky grey, stars trying desperately to shine through the gloom. Globules of rain hung on every branch and blade of grass. Bill bent and unleashed Jimmy, who cantered off, free at last, running over the grass, oblivious to the soaking he would get.

Bill and Milly smiled as Jimmy ran. They walked after him over the wet grass, both gum-booted and free from wet feet. An earthy smell reached their nostrils, mixed with stale dog urine from the many doggy visitors to the park. Milly and Bill strode on, enjoying the fresh air and sense of autonomy the park always gave them.

Then, in the distance, walking alone, they both caught sight of a man. He looked to be dressed in some sort of uniform. There was something odd about his quiet movements. A queerness, a weird kind of air about him. Something not quite right. Or not quite human. It was as though he shone in some peculiar way. A sort of dull light emanated from him, making him eerie in the failing light.

Bill and Milly instinctively called to Jimmy, who was busy sniffing every clump of grass and cocking his leg. He had on his 'deaf ears', as Bill always called it, and took no notice of his owners' calls. Milly and Bill kept on calling him, but he ignored them, thrusting his nose into the grass and reading the calling cards left by other dogs. Eventually, to the distress of Bill and Milly, the man was nearly upon Jimmy, whose head was still buried in a clump of grass. Suddenly Jimmy looked up and saw him. His tail went between his legs and he let out a yelp of surprise, before taking off at a rate in the opposite direction. This was unusual for Jimmy, who generally loved everybody, and would wag his feathered tail like a flag, and greet strangers like old friends.

Is there a Nazi at large in those bushes? (*Silver Star*)

Bill got fearful that Jimmy might run off and get lost in his panic, so he ran after him, raincoat billowing out as he ran. Milly stayed where she was, her hand over her mouth, feeling rather nauseous at the prospect of Jimmy running off into the dark, afraid and alone.

Milly saw Bill stop dead in his tracks when he reached the stranger. He seemed rooted to the spot. Jimmy had stopped running and was stood about a hundred yards from where Bill was standing, looking frightened and confused. His spaniel ears, usually so perky, had drooped around his head, and his tail was tightly down. Milly did not know what was going on, but she didn't like it. Not one bit. She ran then too, towards her husband, the stranger, and the dog.

An uncanny thing happened then, and it was hard to remember afterwards how it did all happen, it was so confusing. The stranger just disappeared. Yes, disappeared, like some magician's trick. Right before their eyes.

Bill, as if suddenly thawed, ran and clipped on Jimmy's lead, then came back breathlessly to his wife. 'Did you see that?' he asked, as if not quite believing his own eyes.

Milly blinked at him. 'I saw that man disappear, if that is what you mean Bill.' He noticed that her voice was a little unsteady. Bill tried to say more, but found that he couldn't, as yet, use his voice.

It was only when they were back home drying in front of the Rayburn, Jimmy rubbed down with a towel and curled happily in his basket, that Bill looked up wide-eyed and said, 'Mill that was a bloody Luftwaffe officer we seen tonight. I seen his uniform as plain as day. I would never have believed it in me life. I think we seen a ghost!'

The Frenzied Farmhouse Poltergeist of Bath

It was 1999. That summer Gordon, a fashion designer of some standing, bought The Gables, a large rambling farmhouse on the east side of Bath. Hughie, his partner, reluctantly moved in with him, leaving their pretty apartment near Primrose Hill in the hands of new tenants on a short-term rent. Hughie was reluctant as he loved London. Hughie had been brought up on a council estate in the Hampshire countryside, and had had quite enough of fields, cows and the smell of muckspreading.

Gordon, on the other hand, loved rural life, and he tried persuading Hughie that the countryside could be fun. Hughie did not believe this, but he was willing to go along with Gordon on what he thought was one of his whims. Gordon had a lot of those. It probably went along with his background. Gordon was from what might be called a lineage. His family was in *Who's Who*. Hughie knew that if Gordon went for a contract somewhere that he would get it. It is a known fact that all good businessmen keep a copy of *Who's Who*. So you see Gordon could not go wrong, could he? Not only that – he was a Mason.

Gordon loved Hughie because he was so beautiful. Hughie was six-foot tall, lean but muscular, and had a crown of blond hair that shone like the sun. Admittedly he was a hairdresser. But this was not expensive hair. Oh no. This was Hughie's blessing from the gods. Thick golden hair that shone like copper wire. It fell in sumptuous serpentine curls over his collar, and he had a widow's peak – a sure sign of deep sensuality. In other words, Hughie was sexy.

Hughie now had a string of hairdressing salons in many places, including London. He no longer needed to work himself. He was rather glad of this. It had become tedious. He loved the gossip, no mistake. But, the stream of female clients day after day, smelling of menstruation, sex, perfume, and sometimes (with the old ones) urine and lavender water, had got too much. And the sob stories. The wailing about men. Once you had heard one, you had heard them all. And then there were the ones that played up to you, somehow believing that they could change your sexual preference. That was the cross an attractive man such as Hughie had to bear. Better to leave it all behind.

The village of Batheaston, in the north-east corner of the county. (*Silver Star*)

So leave it behind Hughie did. He moved to Bath with his lover Gordon. Gordon, who was five years his senior, but looked at least twice that. Gordon had thinned on top at a young age. He was five-foot-eight. He had a bit of a paunch. Gordon liked good food and wine. Gordon was an intellectual. He had been to Eton. Hughie had been to a comprehensive school that was reminiscent of the school in *Kes*. Gordon insisted that Hughie's lack of any real education was what lent to his charm. Hughie told him, 'Tell that to the job centre and see what happens!'

Gordon had taken Hughie to see his parents. They lived in a grand if dilapidated house in the West Country. His mother, horse-faced and charming, pretended not to notice Hughie's lack of breeding, and talked incessantly over the tiny squares of thin-cut cucumber sandwiches. Gordon's father refused to have tea with them and strode out with his Labradors at his heels, not to be seen again the whole time they were there. Which amused both Hughie and Gordon immensely. But made Gordon's mother very uncomfortable.

Hughie swallowed the sandwiches whole. They were, after all, cut into such small squares. What else was one to do with them? He asked for a mug of tea, the cups being far too small. Gordon's mother fluttered her eyes only slightly, went into the kitchen, and returned with a mug, pouring in nearly all of the contents of the pot.

He met Gordon's sister, too. The one married to the banker. Hughie asked if her husband had recovered from the party in London he had gone too. Hughie had been there too; Gordon's sister hadn't. Hughie said he couldn't help but ask, as he had never seen a man ingest so much cocaine before. Also, he wondered if her husband had known that the call girl he had gone off with that night, the one in the pink miniskirt, was really a boy?

Gordon had whisked Hughie off after this, deciding that his family had probably had enough of visitors like Hughie for a while. Hughie was sure that Gordon had thoroughly enjoyed the whole afternoon as much as he had.

Hughie couldn't return the compliment and take Gordon home. His alcoholic father would surely have punched poor Gordon, and called him a poof, among other things. His mother too browbeaten and downtrodden to voice any of her own opinions. She would have just sat in the corner, where she always did, watching television. His own sister had committed suicide seven years back.

It was this tragedy that got Hughie involved with spiritualism. He wasn't a believer in that kind of thing. But one day a rather eccentric-looking woman had come into the London salon. While she was having her hair washed she called Hughie over to her in a rather high-pitched, urgent voice. She told Hughie that she was a medium and that she had a message for him. Hughie was wondering if he ought to call the police, or perhaps a doctor, when she said the young woman who was 'speaking to her' was Annette. Annette was Hughie's sister's name.

It went on from there. And soon Hughie found himself going to spiritualist meetings. Gordon went too, although he never believed in it all, and didn't receive any messages himself. But he could see that Hughie got comfort from it. So why not go?

The next thing that happened was that Helen, the extraordinary-looking lady who was the medium, started to hold séances. These were held at her rather delightful, if smelly, flat in the middle of Oxford. She had about twelve cats, and the inevitable kittens were often not housetrained, there being so many of them at once. Helen invited Hughie and Gordon along to these evenings, along with other prime movers in her circle. These spiritualists were mostly gay, and she flirted outrageously with them, knowing she was quite safe from their attentions.

Helen, draped in black velvet, with numerous silver bangles and dangly earrings, definitely looked the part, perhaps even a little clichéd. She was in her fifties, but still handsome, in a leonine kind of way. A mane of red-gold hair hung in ripples over her shoulders. Dyed of course, thought Gordon, but strong and lovely hair nonetheless. And, for all her theatricals, Helen was a medium of no mean feat. She really was accurate. People travelled for miles, and sometimes even from Europe, to visit her. She refused to charge a penny for what she did, always getting people to donate to her local spiritualist church or an animal charity if they insisted on payment. She wrote articles and an occasional book, and this seemed to keep her going, or at least feeding the growing family of cats.

Gordon's sister came through again in a séance with Helen one evening. She told him that she had come to say goodbye, and was moving on now, adding some other, more personal, things. Hughie was sad and glad. Glad she was moving on, whatever that meant, and sad as he had liked the contact. He missed his sister. She was the only one of his family he had ever been able to talk to.

Despite this Hughie decided that he would still like to go to Helen's 'evenings', as she called them. They were fun. And you often met stimulating people there. Even Gordon liked the company.

The Avon Valley, dominated by the city of Bath. (*Silver Star*)

And so it turned out that in early October of 1999 they turned up at Helen's flat for an 'evening with the spirits', as Helen liked to say. Helen was on good form. Vodka martinis were lined up for 'drinkies afterwards'. Gordon had brought the vodka. Helen was in red velvet with a fine black lacy inlet that showed off her fine ample bosom at its best. The oak-panelled room smelled of joss sticks and cats' piss. No one minded. Four others were there too. Pinky Sheldon and his boyfriend Roger, who were known to Gordon and Hughie, a tall thin man they had never seen before called Barry, who seemed to be grey all over, and a short fat lady with peroxide hair and make-up more suited to a clown introducing herself as Beryl.

Helen threw cats off of the chairs, and asked her guests to compose themselves before the séance. It was really Helen who needed to compose herself; but she always said this to her guests as if it were they who needed to be composed. And they always obeyed her, without a word to the contrary. Helen was used to being obeyed.

Soon they found themselves seated at the polished Edwardian mahogany table. A vase of fresh lilies sat in the middle of the table, beautiful and pungent. Helen declared that these flowers were beloved by the spirits of the dead. They had sat and joined hands, fingertips just touching. Helen went off into a trance. Tinkly New Age music crackled out in the background on an old tape player. Only one candle, placed in the middle of the table, near the lilies, lit the room. It was made of beeswax and a pleasant honeyed smell mingled with the smell of the flowers.

Hughie could also smell Johnson's Baby Powder coming in wafts from Beryl, who was sat next to him. A strong smell of musk and patchouli mixed with essence of cat floated from Helen as she warmed up.

Helen fell deeper into trance and moaned a little. Then a voice nothing like her own came through. A woman's voice, but like that of a girl. 'Barry,' it said. Helen stayed slumped in her chair. The grey man jumped visibly in his. 'Yes?' he croaked out eventually, swallowing hard.

'Barry. It is Claire. Please don't go on worrying about me.' A softness had come over Helen's face. She looked younger. Her rather hooked and proud nose seemed to retreat into her face, and was replaced by a smaller, prettier one. 'I am alright. Why don't you do something about being so lonely? I really can't bear to see it.'

Tears began to trickle down the face of the tall thin man. He tried to speak. But found that he could not. The other people in the room sat quiet, feeling his grief; his relief.

Eventually the thin man spoke. 'Helen can't have known this. It isn't a trick! It sounded like Claire. She looked like Claire!' Tears still fell unheeded.

'Shush!' said Beryl. 'Don't talk. She is starting again.'

All eyes were upon Helen, who was now breathing heavily, her beautiful bosom heaving with each breath. Then suddenly she sat bold upright. Her features again were no longer her own. But this time they were ugly. A heavy, jowled face looked back at them, scowling. The eyes looked dark, almost black, and gleamed with malevolence. Then a guttural demonic voice roared out angrily, 'Get out of the house Hughie Brannon! Get out of the house!'

The grey man jumped in his seat, stifling a yelp. Pinky Sheldon's boyfriend actually screamed. Helen slumped forwards, and Beryl ran to her friend saying in a frightened voice, 'Helen! Oh Helen dear, are you alright?'

Gordon got up and quickly switched on the electric light. He felt afraid despite himself. He wanted some sort of normality brought back to the room as soon as possible. Hughie sat still where he was, staring into space. The tall thin man quickly got his coat, and made his excuses. Pinky was pouring vodka martinis into old-fashioned gold-rimmed martini glasses with hand-painted fly fishing hooks and feathers on them. His hands were trembling. Gordon went over and blew out the candle.

Helen was coming round. She asked what had happened. Beryl whispered to her. Helen shot a worried glance at Hughie, who was still sat stock still. Beryl went over and downed a vodka martini, taking one over to Helen. Pinky and his boyfriend followed suit. Gordon went over and laid a hand on Hughie's shoulder. 'I think we had better go,' he said.

Hughie slumped in his seat in the Mercedes, long legs kicked out. Gordon drove quickly but efficiently, keeping his eyes on the road, saying nothing. But every now and then he glanced at Hughie.

'So... I have to get out of the house,' Hughie said at last.

Gordon jerked his head away, then towards him. 'What house?'

'Don't play fucking dumb. The farmhouse,' said Hughie.

Gordon sighed. He hated it when Hughie used expletives. It was going backwards, he felt. Back to his old ways. He had made it clear at the beginning that everything else was OK, but profanities were not.

'So we are to move are we?' asked Gordon. 'From the house of my dreams, because an eccentric old windbag says some old codswallop in a funny voice.' He was angry. 'And your name is *not* Hughie Brennon.'

'She is not an eccentric old windbag. My name *is* Hughie Brennon.'

'You what?' Gordon was taken aback now. Mortgage deeds, wills, all sorts, each with the name 'Hughie Rowles' signed on the dotted line, flashed before his eyes. It was disconcerting.

'Well it was before my mum changed it. My father was a soldier. A private Jason Brennon. He fucked off and left us both. Then my mum changed my name when she married my "dad".'

Gordon stared at Hughie. So the boy was full of secrets, eh? Obviously there was a lot he didn't know about Hughie, despite their six-year relationship.

'Helen could not possibly have known that. My name I mean. Not that I doubt anything she says. Not after what happened with my sister getting through…'

Soon they were home, back to the farmhouse. Gordon made some sandwiches and poured them both a glass of good claret. He was glad of a drink.

'She did not say the farmhouse,' commented Gordon, swallowing a piece of cold beef sandwich with mustard.

'*It* did not say the farmhouse.' corrected Hughie. 'But I knew what it meant.'

'Hugh, please.' Gordon's voice was plaintive.

Hughie rubbed his eyes. 'This is all mad Gordon. I know that it is. But there is something real scary in it all. Things work through Helen. You know that they do.'

Hughie stayed put. He felt very uneasy over the next few weeks. But he stayed put. Gordon loved The Gables. He had begun to lovingly renovate the sixteenth-century building and to landscape the two acres that were left of the farm. It was his dream home, just as he had said. Hughie did not have the heart to leave it, or to make Gordon leave it. It was indeed a beautiful place, in a lovely setting, near to the amazing city of Bath. The Georgian city was built in the crater of an extinct volcano, and the spas hinted at its geological secrets. The countryside around the house was hypnotic. Green fields, huge old trees, the river winding its way through, sparkling in the clean yellow light like a work of art.

Then, in the third week of October that year something happened. Gordon was back in London working. Hughie was seeing to the house and Gordon's two Border Terriers. Builders were carefully doing renovation work in the house. Hughie could hear their muffled voices as they worked. It was a fine day, but with a chill wind that sang of a winter to come. Leaves beginning to gently fall on the cobbled yard.

Hughie decided to do the dogs' coats – the last trim before the spring. He loved to do this. It was doggy hairdressing. He called to them, and they all went out of the back door to the outbuildings that had once been stables. It was the perfect place to trim the dogs.

They passed Sally, who did the landscaping and gardening. She was dressed in old blue jeans and a red fleece, her ash-blond hair in a pony tail. She was pushing a wheelbarrow with some of the tools of her trade inside. Hughie waved, and the dogs barked in welcome. Sally waved back and went into the kitchen garden, behind the wall.

Hughie went into the old stables and trimmed out the dogs. He only used clippers on the chest and head. The rest was all done with the fingers, pulling out all of the dead hair, streamlining the body with the smart new growth underneath. It was an art. Hughie was good at it. He toyed with the idea of having dogs in the show ring as he worked.

When he had finished he let the dogs back out into the yard, and brushed up the hair. They ran around madly barking, glad of freedom again. Then began sniffing around, leg cocking and play fighting. Hughie decided he had earned a nice strong coffee. He began to cross the yard. Then suddenly, as if from nowhere, a shower of small stones hit him, pelting like rain over his head and shoulders. The dogs, startled, cowered by the back door.

'What the…?' Hughie looked around for the culprits. Were the builder's lads playing tricks on him? But he could see no one. Then he got a strange feeling in his stomach. A feeling

that he recognised as a warning. He had felt it before. It was the 'be careful or don't do it' feeling.

Goosepimples rose on his arms, despite his cashmere jumper. He decided he would go indoors, and walked briskly to the back door and the waiting dogs. But before he could get there another stone flew at him. This time it was as big as a golf ball and it hit him above the eye. He felt a searing pain, and something wet trickled down his cheek. His hand went up to his eye as he cried out. The dogs went into an uproar of barking that brought Sally running from the kitchen garden.

When Gordon came home that night it was to find Hughie with a very swollen left eye, and three stitches put in above it. Hughie looked scared and pale. Hughie had 'phoned Helen. Helen had said that she would be down on Saturday. This was Wednesday. They were to do a kind of exorcism. Gordon was perplexed. Gordon was sure that there was some kind of rational explanation. Hughie sighed and stared at the wall.

They had a subdued dinner and went to bed. A north-easterly wind kept them awake late into the night, rattling tiles and knocking branches against the mullioned windows. Hughie got so jittery that he went down to the kitchen and sat with a huge mug of chocolate laced with brandy. Gordon tried to get some sleep. After all he had a fashion show coming up in two weeks' time. He had lots to do.

Friday night saw them more relaxed. Hughie knew that Helen would arrive the next morning. He took great comfort from that. Gordon was on a high. The show was going to be spectacular. Big names had been attracted. He got out a bottle of Taittinger Prestige rosé. It was too much really, after a Beaujolais Cru with the meal. But Gordon felt like celebrating. Hughie was glad for him, but refrained from all but one glass. He had been told by Helen to keep off of the alcohol for the next day's work.

And so they retired to bed in good spirits. Gordon went out like a light. Excitement and alcohol producing a deep sleep. Hughie soon drifted off, thinking about Helen, who he knew he could rely on to sort things out.

Just after midnight Hughie awoke with a start. He thought that he could hear someone outside the bedroom door. He immediately thought of the gun kept in the case in the corner. Gordon had a licence. His family were hunting, fishing, shooting people. Hughie listened intently for a minute. Yes, there they were again. Footsteps. Footsteps slightly muffled as though walking on soft carpeting. And breathing. Yes. Unmistakable breathing. Heavy. Almost sighing. And rhythmic. Hughie felt the prickles go all over his face, and a light perspiration broke out on his body. Then: *Bang*! *Bang*! *Bang*! *Bang*! Knocks upon the bedroom door that would wake the dead. Hughie screamed.

Gordon was out of bed before he had properly awoken. He ran naked to the gun case. He reached in and quickly loaded the gun. Without waiting, Gordon went across and threw open the door, pointing the gun before him as he went. 'Come on you bastards!' he screamed. 'Want some of this?'

Trembling, Hughie followed, only to find there was no one else there. Gordon ran downstairs, checking every window and door. The dogs bounced around his feet, barking. All was shut and locked. No sign of intruders anywhere.

Enough was enough. Gordon had no explanation for what had happened. Hughie refrained from mentioning the words 'supernatural', 'ghost' or 'poltergeist'. Gordon was just glad that Helen was coming. It was all beyond his comprehension. He had looked for a logical explanation and found none. He was out of his depth. He was all for calling the

police. But in the light of day he realised that there really was no evidence to go on. There were no signs anywhere of human intruders. He would look a fool.

They sat hollow-eyed that Saturday morning, waiting for Helen to arrive. Gordon dressed in black tracksuit bottoms and a white Calvin Klein t-shirt sipping black coffee moodily and reading *The Times*. He had already been out for a run, and he had showered. Hughie, feeling, as he expressed it, 'like shit', was still in pink pyjama bottoms and nothing else, and nibbled at a piece of wholemeal toast.

Hughie decided it was time to shower and freshen up. Helen would arrive around 11 a.m. He went upstairs to the ensuite of the master bedroom. He opened the door. It smelled of bathroom cleaner and expensive soap. It was all white and gold, with a black marbled floor, and it sparkled with cleanliness. He turned on the shower to get it to the right temperature, which it did by regulating itself. He peeled off his pyjama bottoms and stood naked, letting the warm water run in rivulets down his lean muscular body, washing away the miasms of the night.

Suddenly a stench filled the room, making Hughie almost retch. It smelled of long-dead corpses. He had smelled it before when out walking. The culprit was a dead badger lying half decomposed in the hedgerow. Where the hell could a smell like that be coming from? He stepped quickly out of the shower, reaching for one of the deep-piled Egyptian cotton towels in which to wrap himself. Then, to his horror, he saw that the water running out of the shower was bright red. It looked like blood. It was winding its way down the plughole, and for all the world looked like the shower scene in *Psycho*.

He scrambled to turn the thing off, the red liquid running down his hands and arms as he did so. The stench had evaporated. Hughie sat down on the closed toilet seat, still wrapped in the towel, and burst into tears. For God's sake, Helen, hurry up, he thought. I can't take much more of this. What the hell was happening here?

Helen arrived at 11.30 a.m. She parked her rusty little Citroën outside and rang the doorbell several times, as she liked the sound of the chimes. She was wearing a tight-fitting dress of purple velvet with a waterfall of green lace falling from the sleeves. A rather fetching red pillar box hat with a black veil that covered her luxurious hair. She had a large multicoloured velvet bag in one hand. She smelled of Love Potion No. 9 bath oil.

She greeted Gordon with a peck on the cheek, and went over and held Hughie in her arms and kissed him full on the lips.

'I can tell what has been happening,' she said briskly. 'Tonight we are to do the ritual of the pentagram. There is pure evil here without a doubt. It reeks of it. I can feel it. It is in this house.'

Gordon was about to say something, but Hughie looked pleadingly at him and he stopped.

'We are to have nothing to eat until the ceremony is done. Herbal tea and a dry cracker, if you get hunger pangs, is allowed.' Helen went on in a businesslike manner. 'Now dear ones, you must show me around this abode of yours.'

That night, after they had all had 'ritual baths' (Helen had given both Hughie and Gordon certain oils to add to the water), Helen set about preparing the room she considered to be the heart of the house: the sitting room.

Hughie and Gordon stayed in the kitchen after moving all of the furniture to make a space on the vast Turkish rug. Helen prepared the room. They could hear her murmuring softly as she walked the perimeter of the room brandishing a censer filled with sweet-smelling

incense and scattering droplets of blessed holy well water seasoned with sea salt from her long, white, tapering fingers. Now she was dressed in a plain black cotton robe with a hood, tied at the waist with a silver cord.

Soon they were called into the room, and also adorned with plain black cotton robes. She told them to stand in the centre of the room and then she drew out a shining serpentine knife from its sheath and carved an imaginary circle around them all with it.

She made them stretch out their arms in the form of a cross and repeat after her: 'Touch the forehead,' she commanded. Then she said, '*Atoh.*' She vibrated the word in a strange way. They followed her as she proceeded. 'Touch the breast. *Malkuth.*' Her voice resonated as if she were in a cave. And so on they went, doing the Qabalistic Cross.

She used the god names of the Four Quarters while making the circle of the Flaming Banishing Pentagram. She called upon the four Angels of the Quarters. She summoned the Presence of the Six-Rayed Star. She used a Hebrew chant that reverberated around the room, strange and wild as Pan. They finished the ritual with a repeat of the Qabalistic Cross. And as they did so it was if a rushing wind filled the house with deafening noise, somewhere in it a sound like a scream. Hughie clung to Gordon in terror.

Then a window flew open and a few red-gold leaves floated in, spinning as if on some airy vortex. Fresh air filled the room, and with it came a peaceful silence, as if something evil had moved on, and then a feeling as if spring had come after a hard winter.

The Pickpocket Phantom of Wincanton Racecourse

Margot was the only person in the office *not* excited by the prospect of a visit to the racecourse at Wincanton. Suzette, the office junior (though probably not for long, as she always wore short skirts and stockings to work, whereas the other girls favoured smart trouser suits), said the trouble with Margot was that she was always too well-informed.

I mean, who really wanted to know what a three-year-old racehorse's skeletal structure looked like in an X-ray that showed the damage done by weight-carrying before the bones had properly formed and set? Couldn't Margot just go to the racecourse and enjoy herself like everybody else? Suzette, for one, was going to do just that. All that dressing up and drinking champagne could do wonders for a girl. And you never did know your luck, a passing oil sheikh might take a fancy to you and whisk you off to some palace in the desert where you wore diamonds and would be hand-fed with sweetmeats. Well, as long as it wasn't sheep eyes you were fed it sounded like a pretty good life, didn't it?

Margot was well-informed. It made her unpopular. As Suzette said, she was a spoilsport. She put the mockers on the excitement in the office when Big Boss, as he was known, the only man in a gaggle of girls, said they had worked hard and that he was taking them to the racing. Margot had been cried down. She knew when she was beaten. But she knew that she had better accompany them to the racecourse or she might find herself more on the outside than she already was.

It was spring 2004. Big Boss turned up with the people carrier. Margot, Carrie and Julie hopped in. Carrie and Julie had been shopping together and had got themselves similar smart knee-length skirt suits. Carrie in black, Julie in heather. Neither wore a hat but they had fascinators with bobbing feathers in their hair. Carrie looked better in her suit than Julie, Carrie being thinner. She should have worn the heather, though, and Julie the black. Margot had not been invited shopping. She just wore a simple green- and white-striped blouse and a black calf-length skirt. She was far too conscious of her thick thighs to wear any other colour below the waist. Big Boss looked suave in a petrol blue suit that accentuated his bright blue eyes and silver hair. Suzette was not there. They had to pick her up from her house along the way. Trust Suzette to get preferential treatment.

Wincanton Racecourse on a quiet day. (*Silver Star*)

When they got to Suzette's little box of a house – brand new, single-bedroomed, tucked in a cul-de-sac, spotless and smart, everything gravelled, no messy grass – they sat outside for ten minutes. Big Boss did not blow the horn with impatience as he should have done. Oh no, this was Suzette. Margot was sure the horn would have been beeping for ages if it was her they were waiting for. Eventually, Julie, getting really fed up, called Suzette on her mobile 'phone. Suzette told her to tell Big Boss she was sorry. Her suspenders were playing up and she had a job catching one of the fasteners on her stocking. They were real silk, and she didn't want to make a hole in them!

Margot sighed at this piece of obvious titillation. But Big Boss ran his index finger around the rim of his shirt collar, as though he had come over quite warm. Margot sighed again. She knew what sort of day this would be. She turned to Big Boss and asked if his wife would be joining them. Didn't she like the races? Big Boss looked cross at being reminded of his matrimonial duties. He icily replied that his wife was afraid of horses. Julie and Carrie gave her the evil eye. Margot was putting the mockers on things again. She should know better than to upset Big Boss like that. If you didn't upset him he could be very generous. Carrie and Julie had visualised him giving them £50 each to bet with. They would use £20 for betting, and put the rest towards another shopping trip.

At that moment Suzette came out, dressed in a tight red dress and ridiculously high heels. Her long black hair was braided and combed to one side, the plait falling becomingly down her left shoulder. She wore a cocky little red hat, and held a dinky little red patent leather handbag. Her dark eyes glistened as she got in and sat right next to Big Boss, being very

careful that her skirt rucked up a bit to reveal, for only a split second, a stocking top. A waft of Chanel floated to the back of the people carrier, making Margot sigh again.

When they got to the racecourse, even Margot had to admit how colourful it was. The horses – lithe, fit, shining with health, full of a frighteningly explosive kind of energy – were held in check until the off. The tiny jockeys looked like vibrant ants upon their backs. The air was tense with excitement. There was a sense of anticipation in the crowd that was almost sexual. Indeed, Margot could no longer see Big Boss and Suzette. She had caught a glimpse of Julie and Carrie sitting in refreshments with two well-suited and -booted, vigorous-looking, youngish men. The girls were drinking champagne and giggling. The men's animated talk was punctuated by loud laughter.

No one cared where 'put the mockers on it' Margot was. It was the story of her life. She was left to wander, 'lonely as a cloud'. Margot felt the old pang in her solar plexus. It was the pang she had felt so many times before, when everyone always seemed to be having fun except her.

The trouble with you, Suzette had said to her time and time again, is that you won't loosen up. You had a bloke once and look what happened! Indeed. Look what happened. Victor, the 'bloke' in question, had asked Margot out, and she had gone. Victor wrote poetry, was clever and articulate, but he was unwashed, gawky, and careless in his appearance. Margot had enjoyed his conversation. But the smell of his grubby feet had been too much. And she found she couldn't bear to look at his Adam's apple bobbing up and down in his scrawny neck every time he got excited.

The trouble with you, Suzette had said, is that you are too picky. A girl like you can't expect to pick up a Brad Pitt look-a-like. Your skin would need to be brighter. Your eyes wider. Your thighs definitely thinner. And you'd have to do something about the length of your leg between knee and ankle; far too short.

Margot realised that she might have to be somewhat surgically enhanced to get a man. Even though she tried to tell Suzette that Brad Pitt wasn't her idea of an ideal man. But Suzette, as usual, wasn't listening.

Anyway, she had got Victor, but for the reasons mentioned above she broke it all off. The kind of man she was attracted to was never attracted by her. Perhaps Suzette was right and she'd have to be surgically enhanced. But the trouble with that was she knew it to be unethical. You conned others into believing that nature had endowed you with things that she had not. It would all be a lie. Oh, why put the mockers on it again, Margot?

Well, after she had thrown Victor over, he got some work published, and became quite the local celebrity. Suzette began going out with him to posh dinners and to the theatre. Suzette, who had said she wouldn't be seen dead with something so ugly, smelly and scruffy. But there she was, running around with Victor in high-heeled boots, mini kilts, tie-dye t-shirts and thick eyeliner, trying to look arty. It was amazing how a bit of success could make any type of man a catch. When Margot tried to pull her up over this, Suzette just said that it served Margot right. Margot should have just learned to ignore the smelly feet and the Adam's apple. And that although she, Suzette, was certainly going to cash in while Victor had this flurry of fame, she was prepared to bet that it wouldn't last long anyway.

And so it was that Margot, alone again, was walking through the crowds at Wincanton Racecourse. She had no inclination to bet. That would be immoral. She couldn't stop thinking of the state of the horses' backs and those cruel pieces of metal in their mouths. And so no inclination to watch the races either. She didn't like to drink either, as only a glass of champagne caused her a splitting headache.

So she just wandered about aimlessly, hoping that the time wouldn't pass too slowly before they would all be ready to leave again. She began to wish she had feigned illness today. But that would have been a lie! So here she was. She found herself an inconspicuous seat and just watched the people going by.

Very soon she noticed a small dapper-looking man in a red brown suit the exact colour of a fox's pelt. He had a face not dissimilar to W. C. Fields'. But he was thinner, light on his feet, and had a bald pate with a thick growth of ginger around the bottom. He was weaving in and out of the crowds, a beaming smile on his face, speaking to no one. There was something about the way that he moved that was mesmerising. He was a piece of quicksilver. What with his mercurial manner and the ginger hair, he reminded Margot of a weasel. What an odd little man he was. He just blended with the crowd. He seemed liquid, pouring himself from one place to another. No one really seemed to notice him. It was almost odd.

Margot sat watching him, hypnotised. Then he did something that made her heart lurch. He put his nimble little white fingers inside the jacket of a man standing next to him, and dexterously relieved him of his wallet. He moved on swiftly and then opened the handbag of a big-bosomed lady in a floaty blue chiffon dress, took out her purse, and closed the handbag up without her noticing anything had happened at all. Margot just sat staring in horror as the little man worked his way among the crowd, taking money here and there.

She was just wondering what she should do when Big Boss and Suzette appeared. Suzette's dark hair looked a little ruffled, and she was straightening her tight red dress and giggling, pink champagne in one hand, little bag swinging in the other. Big Boss had an arm protectively around her small waist. But Suzette's eyes were now elsewhere. They had fixed on a broad-shouldered, good-looking young man in a slick tailored suit. This did not rile Big Boss. On the contrary, it made him look more longingly at the elusive girl on his arm. Margot shook her head, and sighed with distaste.

While this was happening, quick as a fox darting into its den came the dapper little man, and had Big Boss's wallet in a flash. Margot screamed out and ran towards Big Boss and Suzette, shouting, 'Thief! Thief! Watch out!'

Then a very strange thing happened. The little man disappeared before Margot's eyes as if he had gone up in a puff of smoke. The culprit gone, Margot just stood looking rather stupid under the gaze of a frowning Big Boss and an incredulous Suzette.

'She's been drinking,' said Suzette simply. 'And she's not used to it, you know.'

Margot said that she had definitely *not* been drinking. And would Big Boss please check if he still had his wallet. Margot found herself to be trembling. It frightened her to think that she might have just witnessed a pickpocket ghost.

Big Boss found that his wallet was indeed missing. Only in that split second of exclaiming his loss did a man next to him ask if that was his wallet on the white rail next to the racetrack? And indeed it was his wallet, precariously balanced on the rail, and not a penny missing from inside!

The wallet incident could not be explained. But no one in the people carrier on the way home wanted to hear Margot's uncanny explanation.

'The trouble with you, Margot,' said Suzette, who was hugging her handbag to herself, with the business card of the good-looking young man in the fine Italian suit inside, 'is that you can't go anywhere without trying to put the mockers on it. So if it doesn't happen, you make it up.'

It Shouldn't Happen at the Vets in Whitchurch

Caroline worked at her local veterinary surgery in Whitchurch. The year was 1983. Caroline was eighteen years old and a trainee veterinary nurse. Caroline was petite and slim with short, brown, shiny hair cut into a bob, and wide grey eyes. She was a clever and efficient girl, and she loved her job. She had always loved animals. Even as a baby she would smile first at dogs and cats and other animals, before she would offer the same greeting to humans. Now she had her dream job. Nursing sick animals back to health was the most rewarding thing she could think of. And now she was well on her way to qualifying as a veterinary nurse.

Everyone liked Caroline at the surgery where she worked. She was a steady girl, and could always be relied upon in all sorts of emergencies. She was honest and hardworking, and, above all, she had a real vocation for her job. She was popular with the vets and the other veterinary nurses and office staff.

For this reason Caroline was often called upon to do the night duty nursing, and to help with emergencies in the early hours. She did not mind this in the slightest. She liked being awake in the wee hours when nearly everyone else was asleep. It gave her time to think properly, she always said, the airwaves not being so much in use by other human minds at that time of night. It was then that she would do her studying.

On such a night at the end of August 1983 she drove her little mini to work. It was raining a little, though hardly enough to have the windscreen wipers on. It was a fine, misty drizzle. There was a chill to the air as she parked her car and locked it. A pale, watery full moon looked down in lonely splendour from a cloudy sky. Only a few stars twinkled halfheartedly through the scudding clouds. Caroline gave a little involuntary shudder. Autumn had come early, a reminder of the colder time ahead.

She pressed the front door buzzer. The door was opened by a tall plump girl with brown frizzy hair. The unruly tresses were escaping from a ponytail band. This was Jenny, a fellow veterinary nurse.

'Oh you are a bit early. Good stuff! My boyfriend is bringing wine around tonight when I finish work. Party time!' said Jenny.

Whitchurch, a good place for sick puppies and queasy cats. (*Silver Star*)

Jenny, though plump and with spotty skin and big feet, always had a trail of boyfriends who came and went as she got bored of them. She had startlingly clear blue eyes, and her legs were elegant for her size. She had a bubbly personality, and nothing fazed her. She and her brother, younger by two years, shared a house bought for them by their parents. Jenny was twenty. Caroline was in awe of her independence. Caroline still lived at home with her parents. Caroline wished that she had a steady boyfriend, but was worried in case romance got in the way of studies. Besides, she felt as though she was too thin, too gangly, too... oh, everything!

'Nothing much going on,' went on Jenny in her lively voice. 'Old Monty is back again with a rat bite gone septic. God that cat must be old! Watch out when you see to his medication. He bites and scratches like the Devil. His owners won't have the money to pay again, you can bet. Goldie the retriever. Goldie I ask you! Inventive name, eh? I blame *Blue Peter*. She is still on the drip and poorly after the hysto op. Pyometra. Nasty. Left too long. Still, Mr Fern says he thinks she'll pull through. Oh you should have seen Mr Fern today Caro! God he looked gorgeous! He was all dressed up to go to some West End show with his wife. Dinner jacket, the lot. Wow!'

Caroline looked back wide-eyed at Jenny. Mr Fern, one of the vets, was a bit of a heart throb. He looked like a cross between Rudolph Valentino and Clark Gable – dark, muscular, full of shadowy passions and nervous energy. Whereas Mr Ley, the vet who owned the business, was a dead ringer for George Melly, but without the humour.

'And then there is Philip the guinea pig,' continued Jenny, switching off a few of the lights nearest to the animal cages. 'He's been fitting. But he seems OK now after his med. He seems back to normal. But I've put the dosage out in case,'

'Easy peasy then,' said Caroline. 'Nothing too complex tonight.'

'Hopefully not,' said Jenny. 'Oh by the way Susan rang. She's had to go to A&E with Freddie. He's only gone and cut his toe open. He'd drunk too much wine and fell into their pond. Lucky he only cut his toe eh?'

Jenny and Caroline laughed. 'She says it probably needs a stitch or two. But as he's been drinking she will have to drive him there. She was supposed to help you with the drip on Goldie. Never mind, she'll get here eventually.'

Jenny gave a little shiver. 'Bit chilly tonight. Must be just the autumn setting in. Mind you...' She gave a sideways glance at Caroline. 'Sometimes things get a bit strange here.'

'What do you mean?' asked Caroline sharply.

'Oh I don't know.' replied Jenny. 'My mum calls me fanciful anyways.'

'What are you talking about?' asked Caroline.

'This place. Did you know that in the past there was a morgue here?'

'I wish you hadn't told me that Jenny.'

'Well there was.'

'I don't believe in ghosts and such stuff.'

'Neither did I,' said Jenny. 'But some people draw spirits to them like sharks around a bleeding man,' said Jenny.

Caroline shuddered. 'If I don't believe in them, they can't come,' she replied bravely.

'That's what you think,' said Jenny, pulling on a woollen coat that looked a size too small.

'Oh don't Jenny. Please. I'll be here all alone if Susan doesn't get back from A&E very soon.'

Jenny laid a hand on Caroline's arm. 'I wasn't saying things to scare you hon. Look, you are new here. I am kind of trying to say, "Don't worry if it's a bit weird here at times." That's all.'

'You've seen things here?' Caroline's eyes had widened and her voice was a little shaky.

'No,' said Jenny. 'But I have felt them, so to speak.'

'Oh God!'

'Don't overreact. It can't harm you. Anyway, I thought you said you did not believe in those things?'

'I don't know,' said Caroline. 'I've never thought about it before really.'

'Look I'm off now. Make sure you check Goldie's drip hasn't come out won't you? Like I said, Susan will come and change it with you, if it needs it. Don't look so alarmed. Lights are on. Put the radio on or something. You'll be alright.'

'I wish you hadn't told me this had been a morgue,' said Caroline.

But Jenny was going out of the door. 'Night Caro, see you tomorrow.'

Caroline almost called her back, then stopped herself. This was ridiculous. Obviously Jenny had a twisted side to her character, saying all of that stuff when someone would have to stay in this place alone at night. Caroline wondered how many other veterinary nurses had been frightened by Jenny's malice. She had always seemed such a nice person.

Caroline switched on the radio. It was tuned in to local station. 'Ghost Riders in the Sky' came on, and Caroline laughed. What a coincidence. She suddenly felt better. She busied herself checking on all the animals. Monty the cat stared at her with large wicked yellow eyes. Goldie was sleeping peacefully, the drip still in place. Philip the guinea pig was munching on some lettuce and tomato, and looked at her with bright black inquisitive eyes.

She turned off the rest of the lights near the cages to allow the animals to sleep if they wanted. Then she washed up Jenny's coffee cup and a few other bits and pieces, and tidied the reception desk.

After this she sat in a comfortable chair and revised, looking at *The Merck Veterinary Manual*. She had been doing this for about an hour when she noticed a real chill on the air. She began to wish that she had brought an extra jumper. She looked towards the animals. Their cages were in darkness now. They would be alright – the cages were individually heated. It was as she was staring that way that she got the impression that the room looked somehow different.

In one of the corners of the room she thought she caught sight of a trolley. On the trolley was what looked like a bloody corpse. Its pale limbs hung at strange angles; post mortem came to mind. It was as if students had left for dinner in the middle of some grisly work. Caroline rubbed her eyes. Then the shadowy spectre of a ghastly past was gone as suddenly as it came. Evaporated. Caroline took a deep breath and held her hand to her mouth. She must pull herself together. It was all imagination. It was Jenny's fault.

But the icy cold still remained and would not go. Caroline rubbed the tops of her arms with both hands. She looked at the clock. It was 12.10 a.m. Surely Susan would be here soon? The tick of the clock somehow jarred her nerves. She turned the radio up a little. Suddenly white noise came over the speakers. She tried the tuning knob without success. It made such a row that she gave up and turned the thing off in anger.

She went back to her reading, but found that she could not concentrate. Eventually she threw the book down and paced around. Her heart was beating wildly now. She was afraid. But she did not know what she was afraid of. She tried to still her mind. It was racing off in all directions. She avoided looking into the shadows that seemed to collect in the corners of the room. She was shivering now. Was it the awful cold, or was it fear?

Where the dead live. (*Silver Star*)

The answer 'phone suddenly clicked on, making her jump. It was an emergency call from a farm, and it was immediately directed to the vet on call. The sound of a human voice quietened her a little. She was grasping for some sort of normality. She decided to make a coffee.

Before she could get to the staff room there was a loud *click*. Then the lights went out. Caroline stood trembling in the darkness. She could now see the outside world through the windows. A sodium light lit up the area just outside the front door of the surgery. A few stray leaves whirled by in the breeze. A piece of cigarette paper blew down the road. A pale ginger tom slunk by, love on his mind.

Caroline stood in the darkness, as if rooted to the spot. It was as though she knew somewhere inside, to her horror, that something was about to happen. Her hackles rose. Her body was covered in goosebumps. Monty suddenly hissed inside his cage. Caroline stifled a scream. A face was peering in through the surgery windows. And such a face!

It was a dead face. The cadaver of a man. Pale, waxen, almost yellow. Eyes sunken in their sockets. A ghoul. Lips drawn back in the awful smile of death, showing yellowing teeth that looked too long in the shrivelled gums. The face was pressed against the window, as if longing for entry. A bony hand, with long dirty nails that looked fresh from the grave pawed at the glass.

Caroline longed to scream. But no sound would come out. Her mouth and throat had gone so dry that all she could utter was a croak. She began to pray. She wasn't religious, but she prayed all the same. It was all that she could think to do. She remembered the priest at her primary school telling all of the children one day that if you were ever afraid then you must pray. 'Say the Lord's Prayer,' he had said, 'it is a symbol of protection.' None of them had known what a symbol of protection even meant. But Caroline remembered it now. She shut her eyes against the horrifying spectacle, tremors of fear running up her body.

'Our Father who art in Heaven,' she croaked, shakily.

By the time she had got to 'Amen' she heard a familiar sound that made her open her eyes. She saw the headlights of a car. It swung into a parking space outside. The terrible spectre had disappeared. It was Susan! Oh, thank God, it was Susan!

Caroline did not wait for the buzzer, but ran and opened the door. Susan was stood there. She pushed past Caroline.

'What the hell?? What has happened to the lights?'

Susan went into the staff room and got a torch from the cupboard. 'Why, the trip switch has gone!' She pushed the switch back up with the end of a broomstick. 'There,' she said. The whole place was illuminated again. Caroline stood at the staff room door, pale and still trembling.

'Why, Caroline, are you alright?'

Caroline ran to the older woman as a child might run to its mother after a fright. Susan instinctively held her in her arms for a minute.

'Did it scare you, the lights going out like that?' Susan asked.

Caroline told her everything. She was sobbing uncontrollably now.

Susan listened until she had finished. 'I have never seen anything here myself,' she said. 'But let us say that you are not the first to experience such things here.'

Caroline, though still in a state of shock, felt a little relieved at this information. At least it meant that she was not going mad. Or imagining everything.

'Now let's have a nice hot coffee and do some work,' said Susan. 'There is nothing like good down-to-earth practical things to chase off the spirits of the dead.'

East Somerset Railway's Extra Guest

Maurice Denby was sixty-four and lived alone. He had never married. This was not because he did not ever want to. It was just the fact that the right person had never come along, as far as he was concerned. And when he looked at his meddling neighbour Rosemary Drew, he was rather thankful that the female species was not a part of his private life at all.

Maurice was a retired engineer and he lived comfortably in his small house in Shepton Mallet with his two rather overfed neutered tomcats Riley and Pepper. They were a male household, although all of them seemed to be eunuchs in one way or another.

Maurice had read in the local paper that Churchill's funeral carriage was being renovated at the East Somerset Railway in West Cranmore. Maurice had driven along to see this and had been much impressed. Being a steam fanatic, he had been to the railway many times, and he enjoyed himself thoroughly. He had drunk many a cream tea on board the Mendip Belle, and occasionally had a leisurely lunch in the restaurant in what had once been the goods shed at Wells. The Lodge Hill station near Westbury-sub-Mendip on the old Cheddar Valley line had been lovingly transferred to the site, and was now a museum.

There was no doubt about it. The railway was a superb place to visit, especially given its superb location in the middle of the stunning Somerset countryside – a fact not overlooked by television and film crews, with whom it was very popular.

One sunny morning in October 2009, Rosemary Drew came knocking at Maurice's door. Riley ran upstairs, a marmalade blur, after seeing who the visitor was through the front window. Pepper sat defiantly on the breadboard in the kitchen, his tabby tiger stripes magnificent in the autumn sunshine.

Maurice answered the door, rather wishing he had followed Riley. But Maurice knew that it would be better to get it over with, whatever it was, as Rosemary was a very determined woman. Besides, if you did not answer the door she would be back pronto with the police or fire brigade, saying she thought you had passed on. She had actually done that to another neighbour one day. Maurice knew that it was Rosemary's revenge for them not answering the door. Rosemary was hot on revenge. Rosemary, it seemed, was used to getting her own way.

Maurice opened the door. Rosemary just pushed past. 'That cat of yours is sat on the breadboard again! I saw it through the window. That is so unhygienic, Maurice. Go and push it off at once, and clean it thoroughly! You'll be ill for sure one of these days.'

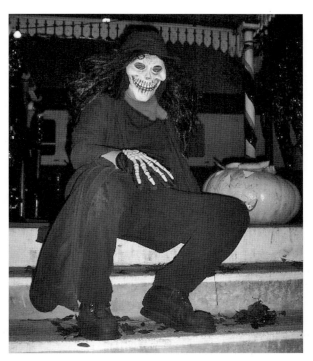

A skeletal fella troubles the haunted rails. (*East Somerset Railway*)

Crone, looking circumspect. (*East Somerset Railway*)

Maurice made no move to do any such thing. So Rosemary went through and shoved a spitting cat from the worktop. 'Disgusting!' she said, washing off the breadboard in the kitchen sink.

Maurice offered her a cup of tea. Rosemary declined. 'God knows what you do with your cups if you those cats tramp all over your breadboard.'

Maurice politely asked how he could help her. He knew the best thing he could do was to play nice. If Rosemary thought she was in for some mind games she would never go; she enjoyed them far too much.

Rosemary patted her plaited bun, and straightened her neat lavender dress and pink cardigan before sitting down in Maurice's favourite chair. She was about five-foot-two, her hair dyed a warm blond, with a big bosom, high cheekbones, grey-blue eyes, and a good complexion, considering she was sixty-seven.

Maurice was a good six inches taller than her, elegant in his way, but with a paunch. Maurice, like his wards, loved good food. He sat solemnly on the edge of the chair opposite to Rosemary and waited for her reply.

'Well,' said Rosemary glaring at him, 'I've come to tell you that you must partner me on the over sixties' outing at Hallowe'en this year.'

Maurice stared back incredulously. 'But Rosemary, I am not a member of the over sixties' club!'

'Oh pish!' said Rosemary, 'How you do make up excuses! Typical man! You do not need to be a member.'

'But Rosemary, aren't we a little old for Hallowe'en celebrations?' Maurice could see Pepper hiding under the Welsh dresser, blinking his big amber eyes in disdain, and he was beginning to wish he could fit under there too, away from this awful woman.

'Oh there you go again! You really don't have much fun in you do you Maurice? Anyway, you will like this. It is a Hallowe'en supper on board a train at the East Somerset Railway. Anyway, I need you to say yes. I am the only one not partnered for the night. Bill Stiles wanted to partner me, but his wife would not have it. Brian Grove asked me, but I wouldn't be seen dead with him. Have you seen how he dresses? He never shaves properly either. He is like a tramp!'

'Rosemary, I am very flattered. But I think I shall have to decline. While I love the steam at the railway, and it is indeed a picturesque place to be, I don't think that I want to gad about on a train for a Hallowe'en supper. There will be too many noisy and grubby children running around. Besides, they will want fancy dress for the evening no doubt?'

'Look Maurice,' Rosemary said sternly, 'I am not going to beat about the bush. If you do not want to accompany me to this important event I shall do all that is in my power to give you hell! Can't you understand? What would it look like to all of the others if I ended up not being able to go through lack of a partner? I shouldn't be able to show my face again at the over sixties'. I would be a laughing stock. It wouldn't hurt you to something different for a change. Stop being such an old stuffed shirt!' Rosemary had got quite white about the gills with passion. Maurice decided it might be safest to back-peddle.

'Alright,' said Maurice, trying to keep face, ' I understand your predicament Rosemary. Maybe you could have put it to me in a nicer way, and I do object to the fancy dress.'

'Oh pish!' said Rosemary triumphant. 'We'll go as vampires, but without the long teeth. Those plastic teeth won't fit over our false ones anyway will they?'

All Hallows' Eve arrived with cloudy skies and only a little nip in the air as the over

sixties' club got into the minibus that was to take them to West Cranmore. The minibus was filled with ghosts and skeletons, ghouls and witches, albeit rather elderly ones. Brian Grove's mummy bandages looked like they had seen a little mud, and some slops of tomato soup. Also his false teeth had broken the night before, so he was now a gummy mummy.

Rosemary sat next to Maurice. She smelled of expensive perfume, and she had bloodied her lips in glossy red lipstick and even wore a black wig. She had on a tight fitting red and black velvet dress from the fancy dress shop that had had 'Sexy Vamp' written on the label. Maurice, who felt embarrassed at the sight of her, was dressed in a black suit, and had whitened his face in a half-hearted attempt to get into the spirit of things.

'Oh this is nice,' sighed Rosemary to Maurice, quite unabashed. 'I think it is going to be a lovely evening.' She looked at him in what she thought was a rather coquettish manner. Maurice thought that the fancy dress, unfortunately, had rather gone to her head.

'Though I do wish Brian Grove would stop leering at me!' Rosemary continued, rather loudly. 'Or I should I say gurning? It's the lack of teeth!'

Soon they were at their destination. A breeze blew a few autumn leaves in their path as they disgorged from the minibus. Someone had brought a flask of punch. Everyone gratefully took a paper cup full of the steaming, fruity liquid.

They filed in to where a beautiful old steam engine stood waiting for the off. On the tank it said 'Warlock's Express'.

'Isn't Warlock a Scottish word for male witch?' asked Maurice, turning to Rosemary. 'We are in the West of England. Not Scotland. Oh well, it *is* an impressive word though.'

'Warlocks to you!' said Brian Grove jealously, then turned and leered at Rosemary. Or did he gurn?

'Offensive little man!' said Rosemary loudly.

Spot the ghoulies! (*East Somerset Railway*)

'Who are you dressed as tonight Rosemary?' asked Janet Stiles, acidly. 'Lucrezia Borgia? You certainly have enough poison.' Janet was dressed as a witch with painted Rice Krispies for warts. Her husband was dressed as Worzel Gummidge, as the fancy dress shop had run out of Hallowe'en costumes by the time he arrived. He stared in open admiration at Rosemary.

'Pish!' said Rosemary, suddenly grabbing Maurice's arm. 'At least I didn't have to come along with Worzel Gummidge!'

Maurice, by now, was thoroughly embarrassed, and wished he had never agreed to come. He thought longingly of being comfortable in his chair at home by the fire with a brandy, Riley on his knee, listening to Trevor Fry on the late show.

Soon the ghouls, ghosts, gurning mummies, witches, warlocks and Worzels were all aboard for the Hallowe'en supper. Other witches, warlocks, ghosts and ghouls were there too, some of them children, but there were no other Worzels.

The carriages had been decorated wonderfully with witching paraphernalia. Cobwebs and spiders hung from the ceiling. Skeletons rattled in the corridors. Bats swooped from above the tables. Each table was lit by tea lights and covered in spooky cloths.

Rosemary was steering Maurice to seats away from Janet and Bill Stiles. Eventually they found themselves opposite Frankenstein's monster and a zombie woman. Luckily they did not really know Rosemary too well, or Maurice for that matter, so were inclined to converse with one another throughout the meal.

As the train took off, Rosemary prattled on, sipping at a huge glass of red wine and laughing at her own jokes. Maurice wasn't listening anymore. He enjoyed the food, and had plumped for a pint of the local cider, which was on special offer. He began to relax and look around.

Rosemary wasn't really bothered whether she had his full attention or not. She was enjoying herself. And she would occasionally look over to Bill and Janet's table to see if his eyes were upon her, which they were. She was gratified.

Maurice, idly gazing around, noticed that over on the opposite table was a ghoul and a skeleton not belonging to the over sixties' club. They had a young daughter with them, a pretty girl with long dark hair. She was dressed as a pumpkin, all orange and black. Next to her was an empty seat. The young girl was quite animated. The family were obviously enjoying themselves.

Rosemary was asking Maurice if he wanted another drink, so his attention was drawn away from the family for a minute or two. When he looked again, a rather stunning woman of about thirty was sat next to the little girl. She was dressed in what looked like a Victorian-style black silk dress, very expensive looking, with a lovely white lace trim on the bodice. Her features were classically beautiful, and she had pale blue luminous eyes and dark brown hair with a reddish hue. She had little or no cosmetics on her perfect face, save perhaps for a little powder. Her translucent hands rested upon the table, and she just sat with an air of grace and tranquillity among the chattering family. Maurice was entranced.

If he didn't think it too over-romantic he would have said one could have fallen in love with a face such as hers. His heart lurched a little as he looked at her. He tried to catch her eye. But no, she was having none of it. She simply would not look his way. Why should she? He was an old man. He felt a pang, something he had not felt over a woman before.

Rosemary was chattering again. Complimenting the pumpkin soup. Maurice felt annoyed at her commotion. He wanted just to gaze upon that beauty undisturbed. He tried to listen to

The dark night of the soul is over... (*East Somerset Railway*)

Rosemary, but failed. His eyes were already straying back to the goddess seated opposite.

She was still sat, hands on the table, in contemplation of something of which he knew nothing. Perhaps a lover? Again, a pang that hurt somewhere in his heart. The family did not seem to notice her. They carried on talking and laughing, and enjoying their meal and the train ride. He noticed that she sat without food or drink Perhaps she was a girl who worried for her figure. And no wonder – what a figure. Sweet-bosomed with a tiny waist that curved into slender hips. She was, indeed, a sight to behold.

Soon the meal was done and the journey had ended. Rosemary, a little tipsy on several glasses of red wine and replete with good food, stood up unsteadily and took his arm. Maurice almost threw her hand off but decided against it. He looked over to where his goddess had sat, but she was nowhere in sight. The family was moving to leave.

Rosemary, on seeing where he was staring, said, 'I think they had a good time don't you? I know I have. I think everyone has had a good time. The train is a joy isn't it?'

'Yes,' said Maurice absentmindedly, wondering where his goddess was.

'Strange there was an empty seat though,' said Rosemary as they dismounted from the train.

'What empty seat?' asked Maurice.

'The one with the family and the little pumpkin girl.' replied Rosemary. 'These events are usually quite full. In fact I've been told that unless you book really early you can't get a seat.'

'But that seat wasn't empty Rosemary!' exclaimed Maurice.

Rosemary frowned at him quizzically. 'Oh yes it was Maurice. It was empty for the whole trip!'

The Gnome of Cheddar Caves

Sandra Morris had decided to take her children to the Cheddar Caves. She had twin girls, India and Shelley. Sandra was a single mother, the girls' father having left when they were just two years old. That had not prevented Sandra from working full-time in a hairdressing salon in Yeovil. Her mother had helped out by looking after the girls.

So one sunny Wednesday in August 2000 Sandra packed a picnic lunch, and she, her mother and the twins set out on their journey to Cheddar to see the famous caves. The twins had not visited the caves before, so were full of excitement on this their seventh birthday. They kept asking questions about cavemen and sabre-toothed tigers, and other things that neither their grandmother nor mother could really answer for them.

This made Sandra feel rather inadequate, and she wished the girls would take an interest in a cut or a colour, or even nail extensions. She would have been able to have answered them with confidence on such subjects. But no, the girls stubbornly refused all interest in hair or beauty, and took after their father (or so Sandra often said, meanly). They always had their little noses in books on history or geography or geology. Both had been able to read by the time they were three.

After a bit of a hazardous journey – Sandra wasn't used to driving around the hairpin bends that were part of the gorge – they arrived. They parked in the car park built there for tourists, outside Gough's Cave. Sandra looked quite lovely in a white shirt and tennis skirt, which showed off her sunbed tan a treat. Her long hair was nicely highlighted pale red and blond. She was extremely careful not to damage her nail extensions as she sorted through the bags to make sure the girls had a drink to take with them. Her mother commented on how looking up at the cliffs of the gorge made her feel quite dizzy. The twins laughed at this, and said they wanted to find a way of climbing to the top. Their grandmother was horrified and begged Sandra not to let them do anything of the kind.

It was a magnificent day. The sky was clear and a powder blue. Great birds of some kind wheeled over the clifftops. India swore they were buzzards. She said she has seen them in a book. Their grandmother said she thought that buzzards didn't come from England – she had seen them hovering over dead bodies in cowboy films. Shelley laughed and said that

Bikers in the gorge. (*Silver Star*)

there were definitely buzzards in England. Sandra said she didn't know what they were all going on about, did it matter what sort of bloody birds they were? Then she realised that she had sworn in front of the girls. 'Damn,' she said.

The place was full of tourists. There was a whole coachload of Italians, and another one of Germans. They had to get in a long queue for the caves, and Sandra was glad that she had remembered the mineral water for them all. Fizzy drinks were only allowed as treats. Sandra believed in keeping her teeth nice, and taking care of her figure. The younger you started, the better.

The sun beat down relentlessly, and Sandra took sunscreen out of her bag and put it on everyone. It was near midday. A lot of the children in the queue were getting restless. Babies were grizzling in their pushchairs, and some of the other children were running about noisily, playing games. Some parents were getting irritated. A few were shouting at their offspring. Sandra made the girls stand quietly next to her. She didn't want them getting lost in a place where there were so many people. The twins did not mind this. India had brought a book with her all about the caves. She and Shelley stood inspecting the information and pictures.

When they eventually got inside the caves the girls were amazed by the stark beauty so far beneath the tons of gorge rock. The coolness of the caves was welcome after the searing heat outside. Sandra's mother did not like it a great deal, being fearful of so much rock above them (maliciously pointed out by one of the guides, she thought), nor the deep pools of water

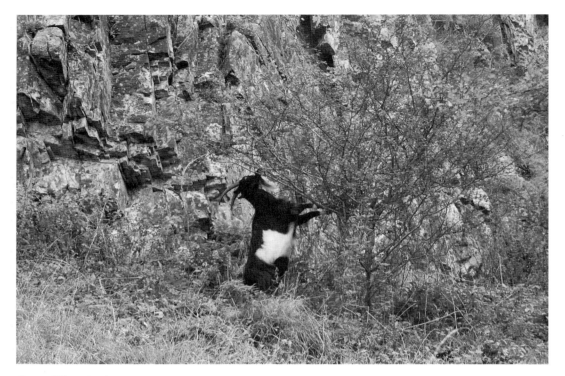

Goat. (*Silver Star*)

occasionally encountered as they made their journey through the caves. She held on tightly to Sandra's hand as if she were the child, while the twins ran ahead laughing.

Sandra didn't care either way. She had, of course, come to the caves several times as a child. It was all just rock – and dark, damp, dank, black water that looked rather unhygienic. Sandra couldn't quite understand the 'aesthetics', as the guide had called them, of these great natural cathedrals of rock. But Sandra's girls' eyes shone with delight on perceiving them. Sandra was glad she had brought them for their birthday treat. But she did start to wonder if she ought to have brought her mother, who had held so tightly to her hand for so long that she had pins and needles.

It was thus stood, looking at the Aladdin's Cave Mirror Pool and listening to the guide telling a little of the history of Gough's Cave, that Sandra saw something very peculiar indeed.

The guide turned to his audience. 'Gough's Cave,' he said, 'so-named after one Mr Richard Cox Gough of Lion's House in the village of Cheddar. He found and excavated the cave between 1892 and 1899, although sections of the cave, then called the Sandhole, were known prior to the nineteenth century. The cave is ninety metres deep and 2.135 kilometres long; that is 295 feet deep and 1.33 miles long, in English. The geology is limestone. The water you see is from a river called the Cheddar Yeo, and this river is the largest underground river system in Britain. The greater part of the cave is only accessible by cave diving. So get yer wet suits on if you want to see more. Ha!'

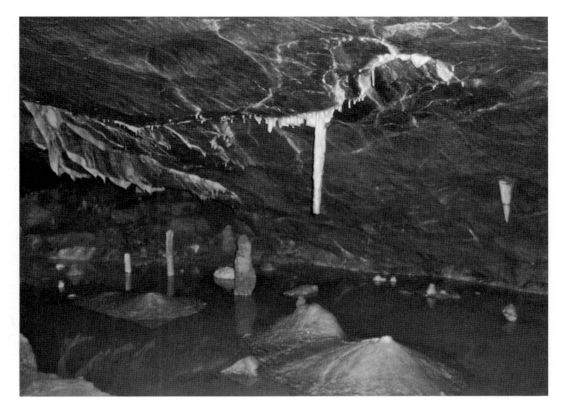

Stalactites in the Cheddar Caves. A favourite haunt of tricky gnomes. (*Cheddar Caves and Gorge Photos*)

'In 1905 the remains of a human man, now called the Cheddar Man, were found just inside of the entrance to this cave. This is Britain's oldest complete human skeleton, and it is now held in the British Museum. There is a replica to be seen however in the 'Cheddar Man and the Cannibals' museum, here in the gorge. As you may guess from the name of the museum, there was a suggestion of violent death to Cheddar Man, and suggestions of cannibalism. He may have been captured from another tribe. They obviously had takeaways even then. Ha!'

'And talking of food. You will notice, as we traverse the different chambers, the large crates of the wonderful local cheddar cheese maturing down here in the cave. This is how it gets its distinctive flavour – through maturation in a certain climate and temperature known only in the caves. You can buy this in various shops in the gorge. Try it with the local cider.'

'Here we have Aladdin's Mirror Pool...'

But Sandra wasn't listening anymore. For out of the corner of her eye she saw something she found it hard to believe she had actually seen.

By one of the rocks near the pool was a tiny man. He was about two feet in height and his skin was brown and he had twinkling blue eyes under bushy white eyebrows. His nose was rather large and hooked. His head seemed a little too large for his body, and his face was wrinkled. He was dressed in brown shirt and trousers of a rather coarse material, and he had

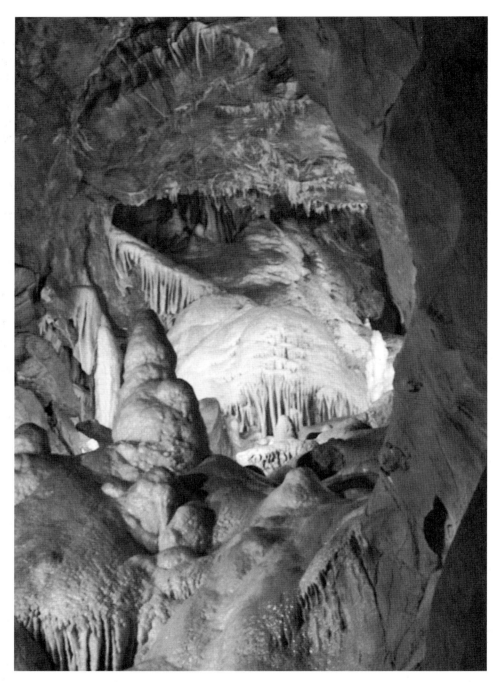

Be careful what you wish for... (*Cheddar Caves and Gorge Photos*)

black boots on his feet. He was staring directly at Sandra in a rather disconcerting way.

Sandra suddenly came over rather faint. She steadied herself against a rock. She took some deep breaths. She decided that she must have been overworking. Now she was seeing things! She cautiously turned her eyes back to where she had seen the little man. He was still there, staring at her!

Sandra was glad when the guide moved them on. She stole a glance back as they all moved off. She couldn't see the little man. No one else seemed to notice him. If they had, surely they would have said? Perspiration had broken out on her neck and face, despite the cool of the cave. How ridiculous! Was she going mad? Surely sane people didn't see gnomes, or whatever *it* was?

Sandra said nothing of this on the way home. The girls were pouring over a guidebook of the caves, and Sandra's mother had dozed off. Sandra decided that it was best to keep quiet about what she had seen. Or rather what she thought she had seen. It could not be true. Perhaps it had been some trick of the light? She was desperately trying to convince herself of some logical explanation.

In the next couple of weeks Sandra, being very busy at work, had all but forgotten about the incident in the cave. Well, not exactly forgotten, but she had put it safely to the back of her mind. And the girls suddenly had a windfall. Sandra's mother had bought them some premium bonds when they were two years old. One of these came up and the girls had won £500! Then India suddenly told her mother to buy raffle tickets for a local charity. Sandra won £50. She was astounded. Luck was coming their way. Usually she was one of those people who never won raffles.

Then one evening, as she was passing the girls' room, she heard them giggling. India said, 'Oh look Shelley, there he is again!' Shelley laughed. 'Now what will he tell us to do? Tell mummy to buy more raffle tickets do you think?' Now India laughed.

Sandra did not know why, but she suddenly felt icy cold. It was as though a wintry hand had grabbed her heart. For some reason she kept thinking of the little man she had seen in the cave. She went into her daughters' room. The two girls were sat on the floor. They both looked slightly alarmed at her entry. India looked almost guilty. But they were quite alone. Of course they are quite alone, thought Sandra. What on earth had she expected?

Then, two days later, a Saturday, Sandra was hanging the week's washing out to dry. Shelley came skipping up to hand up the clothes from the basket for her mother to peg out on the line. India, as usual totally uninterested in household chores, was for once alone in her room, reading.

'Have you and India decided what you want out of the premium bonds money yet?' asked Sandra.

'The little man told us to save it,' answered Shelley, 'He promised we would get more.' Then, looking afraid and slightly abashed, she slapped her fingers against her mouth quickly.

Sandra looked at her daughter, round-eyed. 'What did you say?' she asked. But Shelley was running off in the direction of the house as fast as she could. No doubt in a hurry to join her sister.

The hand of fear again clutched at Sandra's speedy heart. For some reason Rumpelstiltskin came to mind. That horrible character in *Grimm's Fairy Tales*. Rumpelstiltskin helped – but he always wanted something in return. Sandra was afraid. Why was she thinking about such nonsense? She could still visualise the little man she had seen in the Cheddar Caves as clear as day. Was she going mad? But what was it that Shelley had been talking of? Was it just

children playing imaginary games? Was it just a coincidence?

Sandra did not know the answer. But some intuition told her to go to the girls and tell them not to talk to this 'little man' anymore. To frighten them into it if necessary.

This, Sandra did. And the girls talked of the little man no more. Sandra did not like to even think about it. Also, luck stopped rolling. Their lives just went on as normal. Sandra breathed a sigh of relief as the months went by. She never did know what it was all about. She just knew that it had happened.

Dunster's Tale of Terror

The nightmare began when Florence first moved into a rather pretty little cottage on the edge of Dunster with her new boyfriend Raymond and her thirteen-year-old daughter Anna.

Florence and Anna had already been through one sort of horrendous ordeal already in their lives, in the shape of Anna's father and Florence's ex-husband, Clive.

When Florence had married Clive two years before the birth of their daughter Anna, Florence had believed that she had met her soulmate, her Lancelot. Florence had been a romantic girl – tall, pale, beautiful, soulful-looking – like one of the ladies in a John Waterhouse painting. Ethereal, even. She was tall with long, wavy golden brown hair that framed a heart-shaped, slightly freckled face with large brown eyes. Her tiny white hands would quiver and flutter like butterflies; they were the only nervy thing in a languid body.

Clive was tall, dark, hazel-eyed, with a weak, slightly receding chin that if Florence had noticed might have told her a bit more about his real personality. But Florence did not notice. She had the notion in her head that Clive was to be the love of her life, and that she would do anything to be with him. Clive was not going to persuade her differently. Florence was, after all beautiful, if silly, and besides, she had parents who were reasonably well-off.

Before and just after the wedding, Clive had been an attentive lover. If Florence had not walked around in an erotic dream, she might have noticed that Clive's eyes were straying to other women very early on in the relationship. But Florence had made up her mind that their life together was going to be just perfect. And if it wasn't, then she would make it so. She even chose to overlook the wedding night, when Clive, blasted out of his mind on God knows what (he claimed it was the champagne), tried to strangle her in a rage about something neither of them could remember – he because he was so smashed, she because she went into shock.

Florence chose to forget this because, as Clive had said so many times, 'You would try a saint, Florence. Really you would!' And Florence knew what a dizzy thing she was. And she knew that she wasn't much good at anything. Why, hadn't Clive told her that a thousand times? He loved her (she was sure of that), and so he put up with her, didn't he?

Things went on thus until Anna was born. By then Florence found herself quite isolated and alone. Clive didn't like her parents. Clive didn't like her friends. Clive knew that they

were all trying to turn her against him. They told lies. And Florence, not wishing to lose her soulmate, withdrew from her parents, friends, and life in general. She stopped playing the violin. She was once in a folk band. Well, she had to give up playing didn't she? The sound of her practising grated on Clive's nerves. He preferred the electric guitar anyway, which he played without passion. Violins were snobbish. Electric guitar was rocky. More working class. The latter puzzled Florence, as Clive's parents lived in a large expensive town house in an upmarket area.

Into this state of affairs Anna was born. Florence was enchanted by her tiny daughter and she just knew that Clive would be too. He hadn't been there at the birth. He had been at a party. He had tried to get to the hospital, he said. But loud music had been on
and he had missed the call on his mobile. But he had come as soon as possible – that is the next morning – with some wilting flowers from the garage on the way. He had some sort of mark on his neck, and he looked awful. Florence was elated to see him, and showed him their beautiful baby Anna. Clive said the baby looked a bit like a screwed up hanky, but she was nice. Florence asked him about his neck. Clive got angry for a moment and nearly forgot just where he was until a nurse frowned at him. Then he told Florence that he had hurt his neck somehow. Then he said he was going home. He was very tired, and when was she coming home? He needed her back at home. Who was going to cook him a meal? She knew how hopeless he was at cooking.

The next few years got worse and worse, and even Florence began to realise that there really was something badly wrong, even though she did her very best to keep the family together now that Anna had come into the world. Clive took to shouting at Florence, telling her to get a job. Finances were not that great as Clive worked here and there, doing decorating, odd jobs, anything. But most of the time he spent taking substances with acquaintances, and having sex with teenage girls who mainly wanted the drugs but had no money to pay for them.

Florence explained that baby Anna needed her, but as soon as she was old enough she would go back to work. Florence begged Clive to go back into education. He was, after all, intelligent. Why not make use of it? This seemed to antagonise Clive to the extent that he head-butted Florence with the baby in her arms. After that, Florence was very careful not to mention further education.

And so Florence and baby Anna learned to live on next to nothing in run-down rented accommodation. And quite often Clive would not come home for days at a time. This was punishment to Florence if she asked too many questions about where he went or what he did. And so she stopped asking. But Clive still stayed away all night on a regular basis. And he would take pleasure in Florence's pain at finding a blond hair here, a sniff of perfume there. Florence said nothing for the sake of little Anna. And because Clive, when drunk once, had told her of his sad and abusive childhood. Compassionate Florence, a girl with deep understanding and wisdom, forgave Clive.

Then one day, when little Anna had grown into a pretty little eight-year-old girl, tall for her age, with brown eyes like her mother and dark hair like her father, Florence asked one of Anna's school friends back to tea. She had never dared before. But on this day Clive had said that he was going to do a job miles away, so would not be home until late. So Jasmine, who was the same age as little Anna, was invited with her mother Marcia.

What fun they had! Jasmine and Anna played with their 'My Little Ponies'. And Florence found that Marcia was interested in music and many other things that Florence loved, and

they talked and talked like they had been friends forever. Marcia was tall, with black, shiny skin like satin, and perfect white teeth that gleamed when she smiled. She was handsome and noble-looking. She was West Indian. Her little girl was a beautiful coffee colour – her father was Caucasian. They dressed in wild prints of vivid colour, and Marcia wore big gold hooped earrings that jangled and shone.

The children had gone out in the garden, and Marcia and Florence were finishing off the sandwiches and enjoying the rest of the Assam bought especially by Florence for the day, when the front door rocked on its hinges as it was opened with force.

Clive came into the room and shouted, 'So this is what you do when you think that I am away bitch?' He grabbed Florence by the arm and wrenched her to her feet. Marcia looked shocked and afraid.

'You bring dirty black bitches into my house eh?' He twisted Florence's arm and made her yelp.

'Please Clive. Don't say such things…' Tears were trickling down Florence's cheeks.

Marcia was on her feet, calling to her daughter. She knew that she had to leave at once. Florence should never have invited them.

'I'll say what I want in my own house!' roared Clive. And he twisted Florence's arm until there was a sickening snapping sound, and Florence fainted with pain as the children ran into the house.

It was after this incident that Florence realised at last that things had got too bad to cope with. In the women's refuge she finally looked at herself in the mirror and saw grey hairs where there had been none, and a tired worn face where youth and beauty had once been. And little Anna was far too thin-lipped and frail-looking. She had troubled eyes. Florence could not stop weeping for months. Guilt took its toll.

Five years later, in 2009, Florence had recovered, although she was scarred. She got herself a job in a small local firm doing admin. It paid reasonably well and she and Anna now led a quiet, untroubled life. Clive had had an injunction against him. He bothered them no more. He never wrote or asked about Anna in any way. Anna did not ask after her father. Florence did not know if Anna thought of him. Anna had grown into quite a beauty. She had the quick nervous energy of her father, and the pale loveliness and grace of her mother. She was intelligent and articulate, but a little withdrawn. She still did not eat quite enough, so was very slender and tall.

Six months previously Florence had stood in for a musician at a folk gig, playing violin. This was the first time in years that she had done so. A friend had persuaded her, despite her pleas that she would be too rusty. Anna had come with her, and enjoyed the evening, which had been a resounding success. There, as they sat around the tables afterwards, sharing a drink, Florence had met Raymond. Raymond helped to set up gigs for the folk club. Raymond was kind and unassuming. He was plump and blond, his hair was thinning a little, and he had bright blue eyes and a mouth that was always smiling. Florence thought he was a little boring. But then she remembered Clive, and decided that Raymond was probably very normal and nice. Florence turned out to be right. Raymond was normal and nice. He took things with her very slowly. And Anna liked him immediately. He never tried to be her father. He was her friend.

So when Raymond asked them if they would like to move into his lovely cottage on the edge of Dunster, they both said yes. Florence could hardly believe all of this was happening. It seemed too good to be true. She warned herself that the furies were always on her tail; even

in good times she was alert. But Florence dismissed this. Her therapist had told her to enjoy things, and not to keep thinking of the what-ifs. Raymond had proven to be a good man. Steady. Compassionate. His father, now dead, had been a minister of the Church of England, and his mother, still alive, was a gentle soul. Raymond did not take after his father's leanings – he was not religious as such – but he adhered to the best of the Christian values, and this made him trustworthy to all who met him.

Raymond had taken them to see the early Victorian cottage in which he lived since the previous autumn. Florence was immediately in love with it. It was made of honey-coloured stone with mullion windows. The front door was of heavy oak with a large metal lion's head knocker. Yellow and orange climbing roses swept up from ground to roof. The large garden was enclosed by a dry-stone wall. The garden was a rampant mass of hollyhock, foxglove, hypericum, fire lily and other assorted flowers. The velvety lawns were full of moss. Raymond had hung fat balls and seed feeders everywhere, including on the large apple tree in the back garden, so a myriad of birds hopped and fluttered, feeding themselves up for the winter.

The inside of the house was in keeping with its age and character. It had been carefully and lovingly renovated by Raymond himself. He only had the experts in to do plumbing, plastering and carpentry when it was needed. It lacked a woman's touch, of course. The towels in the bathroom, for example, were navy. The bathroom itself was clean and serviceable but stark. As were the three bedrooms. The lounge was more like a gentleman's study. The kitchen needed more pots and pans and kitchen implements in general. But there were lots of house plants breathing life into the house. The dining room was fabulous. There was a lovely long mahogany

Horror lurks in Dunster. (*Silver Star*)

dining table and chairs. The seats on the chairs were red velvet. On the table stood a silver candelabrum. It was a room that was full of light, as there were French windows that led out onto a patio in the back garden. The patio was circular, and had been built in mock mosaic by Raymond. A white metal filigree-patterned Victorian patio table and chairs stood upon it.

Florence loved the cottage. Anna loved the cottage. Raymond loved the cottage. All were in agreement that it would be a fresh start and a new life. Raymond had bought it the year before, not being able to stay in the house that he had lived in with his previous wife. Too many memories. Raymond's ex-wife had not been dissimilar to Florence's ex-husband. And then Henrietta – for that was her name – had been killed in a road accident while driving with her lover up the M4 in his Saab. Luckily there were no children to leave behind. Just Raymond, who had found it difficult to come to terms with the death of a wife. Before the accident, he had had no idea she led a double life.

And so it came to be that in the rather wet spring of 2009 Florence and Anna moved into Rose Cottage with Raymond. By the time they had moved in, the whole place had been feminised to their taste. Florence could not get over what it felt like to be cherished and respected by a man. Anna was still a little withdrawn, but doing well at school despite the upheavals. Then strange things began to occur that disrupted all their contentment. Florence, encouraged by her therapist after leaving Clive, had kept a diary for several years. So here is what she wrote of the bizarre episodes of 2009:

Saturday 21 March
We have settled in! Dunster is one of the prettiest places in the world. I can see why Raymond loves it. It is so alive, what with the tourists and all of the pretty shops. The castle is really amazing. Anna and I have fallen on our feet. Raymond is wonderful. So kind to us both. I have a feeling Anna will bloom here. This evening she had had new schoolfriends round. They all went up to her room after supper to play some games I presume. I could hear them up there squealing with excitement over something. My heart has lifted at the sound of Anna actually enjoying herself at last!

Sunday 22 March
We had a marvellous roast lunch cooked by Raymond. He really is an excellent cook! We had a lovely bottle of Fleurie with it, and homemade apple pie and Cornish ice cream to follow. Anna is worrying me a little. When we first moved here her appetite had perked up no end, and she looked lively and happy. Today she played with the food on her plate, and looked somehow troubled and pale. I hope that she has not been suffering from nightmares about the past again. I had hoped they had left her. I so want her to feel as happy as I now do.

Monday 23 March
A strange thing happened today before I left the house to go for an interview for a job at the Tourist Information Centre. I do hope I get this job! It is part-time, but well worth having. Back to the strange thing. Anna was just leaving the house to catch the bus for school when a sudden wind whipped up and a shower of gravel from the drive pelted the windows of the cottage. Some of this hit Anna and grazed her face slightly. The wind was gone as suddenly as it appeared. It must have been one of those dust devils, as they are called. I must ask Raymond when he gets home, as he knows a lot about everything. Perhaps the cottage is situated on one of those strange weather vortexes?

Friday 27 March

I have been busy and not found the time or the need, to write in my diary in the past few days. But now I am a little concerned. Last night I had a 'phone call from the mother of one of the girls who came here for supper on Saturday with Anna. She was most distressed and said that she was worried as to what the girls had been up to. Bethany, her daughter, had been having nightmares since coming here on Saturday. She had said that Anna had a Ouija board, and that they had all played with it! They had sat round with just a candle for light. Then Anna had asked questions and the glass had whizzed around under their fingers. The next thing they knew was that Bethany had been thrown against the wall by an unknown force. This had brought the whole thing to a premature end, everyone now being truly scared.

Bethany said that Anna was into the occult. She had books on Aleister Crowley, the Great Beast. Bethany's mother asked me if I thought it was healthy that my daughter should have such books. She also asked me if I thought it was wise to let Anna have a Ouija board, let alone let other children play with it. She said that she thought Bethany had probably exaggerated about being thrown against the wall, but these things could affect young minds quite badly. Bethany was now afraid to go to sleep because of the nightmares.

Bethany's mother was not antagonistic in any way towards me. She just seemed to think that I ought to know what was going on. And if this is true, then I ought to. I cannot think that Anna would be interested in such things. I have never seen evidence of it. Anna has always seemed such a normal little girl, despite all that she has been through. I cannot say that I have even seen her read the astrology columns in the newspaper, let alone have any other interest in the occult!

There is only one thing for it I suppose. I will have to take the bull by the horns and ask her outright about all of this. I might run it by Raymond first, as he is a wise person, and Anna always listens to what he has to say.

Saturday 28 March

Today I felt that horrible feeling in my solar plexus that I have not felt since I last saw Clive. I discussed what Bethany's mother had told me with Raymond last night after Anna had gone to bed. For the first time since I have been with Raymond I saw anger in his face. He soon got control of it, bless him, knowing how that emotion makes me feel. Anyway I knew that his anger only stemmed from worry. And from past association. Henrietta had been very interested in the paranormal. She had also, unbeknown to Raymond, joined what is called a Coven. Though I do think in Henrietta's case she was more interested in the sexual aspect of Wicca than anything else, mixed with a soupçon of interest in power. It was in this group that she had met the lover with the Saab, which was to be her undoing. So naturally this would be a sore spot with Raymond.

Raymond told me that it would be better if I had a word with Anna about this. He said that he might be influenced by his church upbringing, and so might not have an open enough mind to deal with it. But he was very worried about the use of the Ouija board. And I am inclined to agree with him on this. I have an open enough mind to realise that Anna might be going through a phase of exploration. I do not even mind about the Crowley books, which were probably biography. And, after all, pop stars, celebrities and actors today lead as debauched lives as Crowley, and can be read about in the media every day. But I have grave reservations about the Ouija board. Even though I am not superstitious by nature, neither am I religious.

Dunster Castle – over a millennium old. (*Silver Star*)

11.15 p.m. I need to write before I can sleep. I have had to confront Anna about the Ouija board. I suppose I was half hoping that she would say that Bethany was lying, or that it was just a joke. But she said neither.

While Raymond was watching something on TV I asked Anna to help me tidy the dining room. As she was putting the table mats back into the dresser I casually told her what Bethany's mother had said. I saw her go rigid as she stood there with her back to me. Then she swung round to me, white-faced, and said that it was all true. And that she had every right to read whatever books she pleased. I had never seen her so defiant. I calmed her by saying that of course she must read what she pleased, it was a free country. But I added that I was a little worried about the Ouija board. I asked to give it over to me for now. I promised that I would not destroy it, or throw it away. Anna became extremely agitated at this, her face turning from pale to red and then going pale again. Then she outright said that she would not let me have it, but would keep it under her bed and not use it anymore. Then she left the room like a queen sweeping out. Then there was a huge *crack*, and one of the plates on the dresser fell off and was spinning on the floor.

Saturday 4 April

Things seem to have gone quiet here at home. Anna is on holiday from school for the Easter break. Raymond is to have time off too. So hopefully we can all get out as a family. Raymond is talking about a weekend in Cornwall if the weather looks like it will hold. That would be just so very nice. Anna and I have had so few holidays in our life.

I was a bit worried about the plate incident. But Raymond said it was probably just where Anna had swept past the dresser. An unstable plate might just fall like that. And that I must not jump to conclusions. But he said he was glad the Anna had promised to stop using the Ouija board. He said it was better to forget the whole incident. That way she would

probably forget about the board under her bed, and eventually maybe throw it out herself, as so often children do when they are bored of games or toys.

I am not so sure of that myself. Also I would like to know where Anna got the board from. We certainly did not buy it for her. I am thinking of asking her who did buy it. If she bought it with her own money I can't think where she bought it from. But Raymond says to let sleeping dogs lie now that all has gone quiet. Anna seems more like herself again. She is eating and sleeping better. But I noticed that she does not ask Bethany round again, though some of the other girls have been back. Perhaps it is that Bethany will not come?

Friday 10 April (Good Friday)
We have had a terrible day. We spent most of the afternoon in A&E. Raymond's eighty-one-year-old mother had to have stitches in a wound just above the bridge of her nose. Of course, it being holiday time, there was a lot of waiting about at the hospital.

We went to church this morning. At least Raymond, his mother and I did. They played Mozart's *Requiem*. It was very moving. I have not been in a church in a long time. But obviously, it being Easter, Raymond's mother wanted to go. So we went. Anna declined. Well, that is not unusual for a teenager, is it?

Raymond's mother wanted to give Anna an Easter egg she had bought for her. It was handmade with beautiful sugar flowers on it and a huge yellow ribbon tied in a bow. Raymond's mother really is a love. I can see she is doing her best to make us family.

Anyway, she came home with us after church to give Anna the egg and stop for a light lunch. Anna was so pleased with the egg. I had some homemade vegetable soup and we had this with crusty bread. Then some hot cross buns to follow. As Violet was about to leave, I congratulated myself silently as to how well it had all gone off. Anna walked out with Raymond and Violet to the car to see them off to take Violet home. I stayed behind to clear up.

Then Anna came running back into the house with the news that Violet had fallen over on the drive. I rushed out to see Raymond, his arms around his mother, guiding her into the car. Blood was running down her face. I ran back in and got cotton wool and antiseptic. To my horror it was evident that it was a nasty gash and would need medical attention.

Violet was in shock as we rushed off to A&E. Anna stayed at home saying that she would clear the remnants of the lunch. When we eventually got someone to see to Violet's injury I could hear her talking to the doctor telling him that she had fallen over on the drive. Then I heard her state clearly that she had felt as if someone had pushed her from behind, but that this was impossible for there was no one behind her at the time. Anna had been by her side, Raymond had gone ahead to open the car, and I was indoors.

When I heard her say that, I felt a sick feeling in the pit of my stomach. And the plate from the dresser came to mind. As did the Ouija board belonging to Anna. But how to voice this? I don't think Raymond heard his mother say this. Or if he did he isn't saying anything about it. I think he is in shock. His mother is strong of spirit, but frail in body. Falls like this at that age can be fatal, or at least debilitating; they shake an elderly person's confidence. The hospital wanted her to stay in overnight, but Violet would have none of it, saying that she wanted to go home. So Raymond dropped me off at Rose Cottage and took his mother home to her little house near the sea at Minehead.

A little later Raymond 'phoned to say that he had better stay with his mother, although she was insisting she was alright, and that he was to go home. I agreed with Raymond. She

might get a dizzy spell or something after the shock and the medication. I told him to stay the night, and see how she was in the morning.

Anna was disgruntled. We would have set off for Cornwall in the morning. I had 'phoned and cancelled our booking. There was no way we could go now. I can understand her feelings. Anna had been looking forward to going away. Holidays had been very few with Clive. And the ones we had gone on with him were not very relaxing to say the least. I knew that Anna would come round. She is a compassionate girl. And we have all the time in the world to go away and enjoy a holiday.

Saturday 11 April
Oh my God, what a night!

I don't know what to do. It is still early and Anna is asleep at last. I feel that I can't 'phone Raymond. I don't know how to explain all of this, and I know his mother needs some care and attention at the moment. I don't know if we are going mad. I don't know what is going on. I feel that writing it down like this might make some sense of it. I just don't know.

Last night Anna went to bed at about 11 p.m. We had been sat up watching an old black and white Jimmy Stewart movie. Then, after it ended, Anna went up to her room. I stayed downstairs and poured myself a nightcap. I felt a bit lost without Raymond, if the truth be known. This was a bit of a revelation. I didn't think that I would ever really get attached again after Clive and all that he put us through.

At just after midnight I went up to bed. The events of the day had taken their toll and I felt tired enough to sleep. I think I must have been in bed and asleep for about forty minutes when I heard Anna screaming out. My first fear was of burglars. I jumped out of bed and ran just in my nightie to Anna's room. I flung the door open to find her in her bed, clutching the bedclothes right up to her chin. She looked absolutely terrified. She was crying.

I ran and took her up into my arms as if she were a small child again. I asked what was wrong. She told me that she had heard whisperings near to her when she had got into bed. A voice speaking. The words unperceivable. Then, when she had put the covers up over her head to try and shut out the sound, the covers had been retracted by invisible hands. She pulled up the covers again. Again they were pulled from her. She pulled them up again. Then they were thrown from the bed with real force. She got out of bed, frantic by now, and retrieved the covers again. This was when she screamed and I had come running in.

I tried to persuade her that she had been dreaming. She had suffered from nightmares before when we were living with Clive. I told her to calm down. I asked if she wanted me to make her a warm drink. But she would not let me leave her side. I eventually got her to come with me and get into bed with me as she used to as a toddler. She gratefully got in with me, and I held her until she fell asleep in my arms and the dawn light spread across the dusky pink wool rug in my room.

When she awoke I did some boiled eggs and toast fingers. I am treating her like a baby – perhaps I think it is comforting? For me or for her? Maybe both of us. Now the light of morning is here I am glad that I have not bothered Raymond with this. I think she might just be having nightmares. I keep thinking of what happened to Violet. But she is an old lady. She might be fanciful. The young and the old are known to be fanciful. Once a man, twice a boy. Or whatever gender. Oh God I wish I could make myself believe that it was just imagination. Why can't I?

Sunday 12 April (Easter Sunday)

Raymond came home last night. His sister is staying with his mother. Violet is mending nicely, thank God. I told Raymond about Anna's nightmares and he has been wonderful. We took it turns to sit in her bedroom with her as she was still too afraid to go to sleep on her own. Raymond did the first half of the night with her, I the second. I could see when I took over from him that his face was troubled. But he did not say anything to me, probably because we were within Anna's hearing. She was reluctant to go to sleep at all even though we were there with her. I left the bedside lamp on all night long and took a book to read. At about 3 a.m. Anna dropped off to sleep. The room became freezing cold not long after this. I had to pull a duvet over myself despite having a warm dressing gown on. It is not a cold night outside tonight. I just don't know how it could be so cold in Anna's room. I kept thinking that I caught sight of strange shadows moving on the walls on the periphery of my vision. This was madness, and I was frightened despite myself.

Raymond came along to Anna's bedroom at 3.30 a.m. and silently beckoned me to our room. I could see that he was worried, and his hands were shaking. He had poured a small brandy, which I gratefully took from him. He kept his voice low so as not to wake Anna, and told me that he thought something very weird was going on, despite the fact that he had tried very hard to be logical about it all. He said his mother was still insisting that she was pushed. Now this with Anna. He said he kept on harking back to the Ouija board in his mind. He said he knew that I might think him mad but he also kept thinking about Henrietta. I exclaimed that Henrietta was dead! He said yes, quite. But Henrietta had been involved with occult. He said that Henrietta would have tried to spoil our relationship had she been alive. Henrietta never loved him. She envied just about everybody. He always felt that she wished him ill, somehow. He felt it even now.

I held up my hands at this in astonishment. This was getting ridiculous! A wife from the grave haunting us? It didn't sound right to me. Or sane for that matter. I told him we must not let our imaginations carry us off. Besides, why would Henrietta target Anna? Surely it would be him or me she would hassle. Besides, I did not want to believe that the souls of the dead could or would do such things.

Raymond settled down a bit at this. He sat on our bed looking suddenly quite old and tired. He told me that he was sorry for coming up with crazy ideas. It was just that the whole thing was worrying him. The paranormal was something he just was not
used to dealing with. He said he thought that the paranormal was definitely at work here in this house. He asked if I thought he should talk to one of his late father's friends, who was a priest. I said that if it would give him comfort, then yes. But I am not a great believer in turning to the church. I think I got put off when I was still living with Clive and I went to church one day, a thing I never usually did, but I was so stressed and nearly at my wits end and the vicar just told me to go home and try and keep my family together as it was my duty to do so.

It was at that moment that we heard a scream from Anna's room and we both went running to find Anna sat on the bed holding her back, shivering with fear, the tears trickling down her cheeks. I pulled up her pyjama top at the back and saw a bruise starting to form about the size of a thumb print. And just above it were two livid marks that looked like teeth marks in the flesh.

I knew then that in the morning I must quiz Anna about the Ouija board, and what had happened that night with her friends in her bedroom. Also where she had got the board

from. I knew now that we could no longer pretend that we were not dealing with the paranormal.

Monday 13 April – Easter Monday

None of us really slept last night. Anna fell into an exhausted sleep at around 5 a.m. Raymond went to bed begging me to go too, and get some sleep, as we were all dead on our feet. But I could not. So I went into the kitchen and made fresh coffee and just sat until the sun rose. I couldn't help thinking how beautiful the yellow daffodils and purple grape hyacinths looked, kissed by the rosy glow of a dawning sun. How normal everything looked. The birds busy at the feeders. Insects, just awakening and going about their business drowsily, taking a little time to warm up and find their speed. How could everything look so normal when such strange things were happening within the house? Such questions I asked from an overwrought mind.

Anna came down for coffee and sat with me at the dining room table overlooking the garden. She had shadows underneath her pretty eyes. Her hair was awry. She looked gaunt, not slim. I was suddenly afraid for her. I took the opportunity, while we were alone, to question her a little.

I asked about the Ouija board. I thought, at first, she was just going to run from the room at my asking. But pale-faced she told me that she and her friends had tried the board, asking if there was anyone there. A name was spelled on the board, all their fingers on the glass as it moved: *Samael*. Then, soon afterwards, Bethany was thrown with force against the wall. Anna said that Bethany is so scared that she will not come back into the house. Then Anna broke down in tears. She sat just where she was, sobbing gently. I went over and put my arm about her, and quietly asked her where she had got the Ouija board from. To my great distress she flung away my arm as if it had burned her, and ran up to her room sobbing loudly as she went.

Saturday 18 April

What a week we have had! So much has been going on that I have not been writing in my diary. And I have been so tired through lack of sleep to bother. I usually write just before going to bed.

I will try to put the week in a nutshell. Things just got worse after Monday. More poltergeist activity in Anna's bedroom. I use the word 'poltergeist' as Raymond contacted his father's friend, who turned out to be a lay priest who had also done paranormal research work for one on the universities. He came over on Wednesday and has stayed ever since. He brought some recording material and cameras and other stuff with him. He asked if it could be used for the university. He promised that the name of the cottage and our own names would not go into the public domain unless we specified that it might.

By Wednesday night we had all sorts if phenomena going on. Lights were going on and off. Temperatures changed in all of the rooms, not just Anna's. Plates were moving on dressers. Anna was being pinched again. A plate missed Raymond's head by inches. Bedclothes were being torn off Anna's bed again. I was pushed from behind on the top stair. I was lucky not to fall down headlong. Then we heard banging on the walls. Footsteps sounded overhead when we were downstairs. Our nerves were completely frayed. The only person who was calm throughout was David, the paranormal investigator, who seemed more excited than alarmed.

I had got to the stage where I was so afraid that someone really was going to get hurt by this thing, whatever it was. After all, Violet had been hurt, and I had nearly taken a tumble down the stairs. Anna had bruises all over the place.

On Friday David took me aside and told me that he thought I really needed to talk to Anna. He said that poltergeist activity was thought to manifest itself around adolescents, especially if they were troubled by something. He said Raymond had told him a little of our troubled past. He asked me if I thought that Anna was still disturbed over anything. I told him that I thought that Anna had settled well. She liked the house, the location, the school, she had made friends easily here, and she liked Raymond. I said I thought she was less troubled now than she had been for a very long time. He seemed a bit perplexed at first, then he said he thought I should ask Anna again about the Ouija board. Perhaps something had been going on about which I knew nothing.

David and Raymond went into Dunster leaving Anna and I alone. I knew that David had engineered this so that I could have a one to one with Anna. I made a pot of tea and we went into the garden as it was a sunny afternoon.

After a bit of minor chit chat I asked Anna again about the board. I thought she was going to run off again. But instead she burst into tears and told me that her father had given her the board. She said that she would tell me everything if this would all stop. She was really frightened now and wanted it to stop. I told her that we did need to know everything so that David could help us.

I was astounded at this as there is an injunction out on Clive, and he was supposed not to be in contact with either of us. But apparently he had been meeting up with Anna. He had called her on her mobile, the number of which he had traced through one of her friends before we moved. Anna cried as she told me that she still loved her father. But she had forgotten how bad he was. Soon he was not turning up when he said he would. He also had a girlfriend who was not much older than Anna herself. This girl was interested in the occult. She was the one who lent Anna the Crowley books. She had a Ouija board. Clive didn't like her using it. So he made her give it to Anna. Anna, still sobbing, said she was sorry that she had lied in the past, saying she was staying with friends when really she had been staying her father and his girlfriend.

I could see now how torn Anna must have been. Wanting to see her errant father still. Not wanting to disturb the equilibrium here with me and Raymond. And, she was right. I would have made a real fuss about her seeing Clive. And trust Clive to fob off a dangerous thing like a Ouija board onto his teenage daughter to rid himself of it! Clive was superstitious about such things.

So that was why Anna had wanted to keep the board. It was the only thing her father had actually given her. Presents and birthday or Christmas were never actually bought or wrapped by her father. I did them, putting his name on the label, trying to guard her from the hurt of it all.

It was as we sat there, Anna telling me her story, when one of the upstairs windows flew open and a vase came crashing down at our feet, making us jump. I looked up to see the window swinging gently in the breeze, and no sign of anything else. I felt angry now. Enough was enough! Our lives disturbed by Clive again! He was nothing to do with us now, but he had somehow, as if by some strange metamorphosis, crept into our lives as a disruptive form yet again. Anger had replaced fear for me.

Anna looked at me with saucer eyes. Saying sorry mum, again and again. I told her that it

was OK. No need to worry. We would get all this sorted somehow. And, it was as if a kind of calm had come upon us both sat there in the spring sunshine. As if a boil full of poison had burst in Anna and she had told the truth at last. She did not have to hide things as Clive had always taught her to; she did not have to pile up guilt that did not belong to her.

Soon David and Raymond returned home. David looking dapper in a crisp white shirt and tweed trousers, his grey hair blown askew by the breeze. He looked much more like a scientist that a priest.

I sent Anna to the house of one of her friends. I called them first and told Anna that it would be good for her to get out of the house for a while. Which was true. But it gave me time to discuss things with Raymond and David. I asked Anna if I could tell them what she had said. I said David would need to know everything if we were to stop this stuff from happening. I called it 'stuff'. I don't know what words to use. 'Poltergeist' seems too scary a word to use.

David listened carefully to all that I told him. Like a great bird, he held his head almost on one side while listening to me. He sighed a huge sigh when I had finished. He said that he was almost sure that the activity did centre on Anna. The Ouija board might have been a focus. But it was probably more about her emotional state. Her father had obviously stirred up old feelings again. So much for a young girl to get used to. So much change. And too many secrets. He then he went on to say that we needed Anna to talk about her feelings with us. But first he would do a house clearing, and a house blessing.

David then proceeded to go around the house with holy water and incense and he did a kind of purification of the house. When Anna came back he got us all into the dining room and he did some purification with us, and said a prayer. We all joined in. Straight after this Anna started to cry. She cried as if her heart would break. She said that she loved me and that Raymond was a good man. She said she still loved her father, even though she knew now that he could not really love her. She showed extraordinary wisdom. She said Clive was like a naughty little boy in a lot of ways, a destructive one. He could not love her as she wanted him to. She realised that now. He just wasn't able. When she had seen him last he was bitter about me and Raymond. About where we lived. About the money he thought we now had. He said that we were turning her against him. Anna said she had felt so very bad about all of this. It had built up inside like a volcano about to erupt. She had felt so torn. She could not stop loving her father, despite his previous bad behaviour.

As she was saying this ornaments fell to the floor. Pots fell in the kitchen. *Smash and crash*! *Smash and crash*!

Raymond looked alarmed. I was afraid for Anna. But David held onto Raymond's arm. And he willed me with his eyes to sit still where I was. Anna just kept on crying, seemingly oblivious to the noise of breaking things. Then, all cried out, she stopped. The house became silent. David got up and spoke softly. He said it was over. He could feel it. He told me to take Anna and get her to eat something, if only a biscuit. And I took her to the kitchen, tears streaming down my own cheeks.

David was quite right. It was the end of it. There was no more activity. Our lives are getting back to normal now. It has all seemed like a bad dream. But it was not a dream. It was very, very real.

About the Author

Sonia Smith was born in a little Wiltshire village and has been interested in witchcraft, local folklore and the paranormal for as long as she can remember. Her family on her maternal grandmother's side has lived in Wiltshire for generations. They are country folk – people of the rolling chalk downs.

Sonia has had two books on the paranormal published to date, *Wiltshire Stories of the Supernatural*, and *Hampshire and the New Forest Stories of the Supernatural,* both published by Countryside Books. She has also written articles on witchcraft and folklore. One day she might get a proper job...